# Mollie
## MAKES
# FEATHERED
# FRIENDS

♥making ♥thrifting ♥collecting ♥crafting

MAKE IT YOUR OWN

CUTE BIRD CHARACTERS

# CONTENTS

04    FLIGHTS OF FANCY

06    FELT APPLIQUÉ OWL KINDLE COVER

10    3D FELT FLYING PARROTS

14    NEEDLE FELT CHICKEN FAMILY

20    PAPER CUT BIRD GREETING

24    CROSS STITCH ON CANVAS LOVING LOVEBIRDS

28    SIMPLE INTARSIA PITTER PATTER PURSE

34 ★ FEATHERED INSPIRATIONS

36    FELT EMBROIDERED BIRDIE SEWING SET

40    CUTE CROCHET PENGUIN PILLOW

44    RETRO-FABRIC BIRD CUSHION

48    EMBROIDERED BIRDHOUSE HOME TWEET HOME

KNIT, CROCHET,
SEW, EMBROIDER

PAPER CUT
AND STAMP

52  EMBROIDERED APPLIQUÉ SWALLOWS CLOTHES PIN BAG

56  FABRIC STITCHED PARROT ON A PERCH

60  FELT APPLIQUÉ COCKEREL COZY

66 ★ CRACKING IDEAS

68  WIRE AND BEAD BIRDCAGE DREAM CATCHER

72  STAMPED AND SEWN PARTY BIRD BRUSH ROLL

76  FUN TO CROCHET NESTING CHICKS

80  LINO-CUT WOODPECKER NOTEBOOK

84  GRANNY SQUARE LITTLE BIRD BABY BLANKET

90  WORKING THE STITCHES
91  TEMPLATES
95  CHARTED DESIGN
96  ACKNOWLEDGMENTS

# FLIGHTS OF FANCY

Featuring crochet, knitting, sewing, felting, papercraft, and more, we've gathered together a fabulous flock of Feathered Friends. Delightfully quirky birds in every shape and size, from chickens to owls, parrots to penguins, roosters, lovebirds, woodpeckers, and many more. Each one is lovingly crafted in the signature *Mollie Makes* style.

Containing over twenty new projects from *Mollie Makes* magazine's favorite designers, Feathered Friends showcases our passion for handmade. In today's hectic world we're finding out how satisfying it is to slow down and take up our knitting needles, crochet hooks, and sewing kits again.

With delightful accessories to keep for your own home, plus things to make and give as gifts, this little book of birds satisfies the growing desire to create something personal, fun, and unique. Perfectly named needlepoint designer, Emily Peacock, presents her beautiful lovebirds design stitched in bright tapestry wools. Or if penguins are your penchant, crochet expert Ilaria Chiaratti has the perfect pillow to pick you up. Do you know someone who keeps chickens? One of *Mollie Makes'* favorite designers, Gretel Parker, shares her needle felt skills and creates an entire woolly chicken family.

Don't miss Mollie Johanson's birdhouse: mixing embroidery and brightly colored felt, it's very cute indeed. If you're looking for a twist on the ever popular granny square try Greta Tulna's Little Bird Crocheted Baby Blanket – every other square is a plump birdie. I'm not allowed to have favorites, but I do love Charlie Moorby's owl design felt Kindle cover in orange and gray. Who-whoo!

All the projects are easy to follow with clear step-by-step photographs and instructions, plus handy tips along the way. Many are suitable for beginners, but the *Mollie Makes* ethos is to give it a go and be proud of the end result. We positively embrace imperfection!

Here's to living and loving handmade …

*Jane*

Jane Toft
Editor, *Mollie Makes*

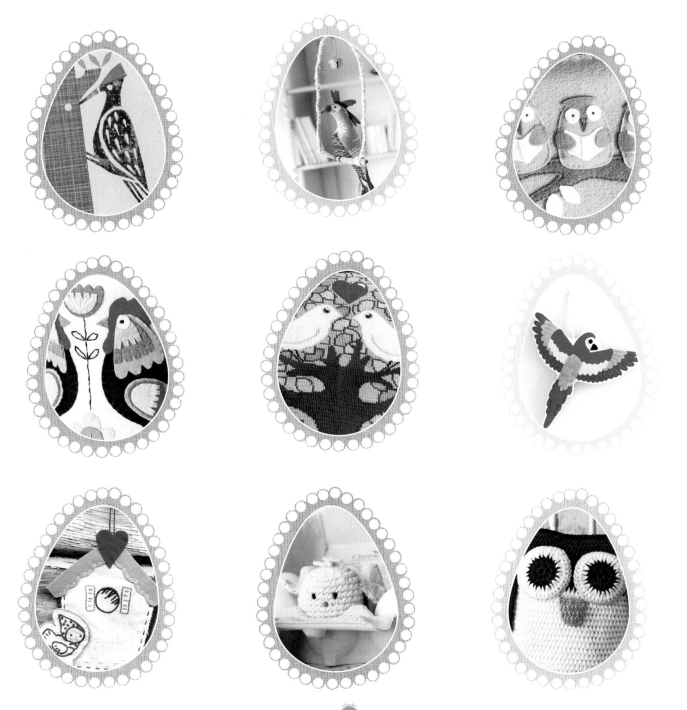

## FELT APPLIQUÉ
# OWL KINDLE COVER

KEEP YOUR KINDLE SAFELY STORED INSIDE THIS SIMPLE FELT COVER DECORATED WITH THREE
WISE OWLS. A GROWN-UP GRAY AND ORANGE COMBO HAS BEEN CHOSEN, BUT IF YOU
PREFER A MORE FEMININE LOOK, TRY RICH PINKS AND PURPLES INSTEAD. TO ADAPT THE
DESIGN TO SUIT ANY GADGET, SIMPLY REDUCE OR INCREASE THE NUMBER OF APPLIQUÉ OWLS.

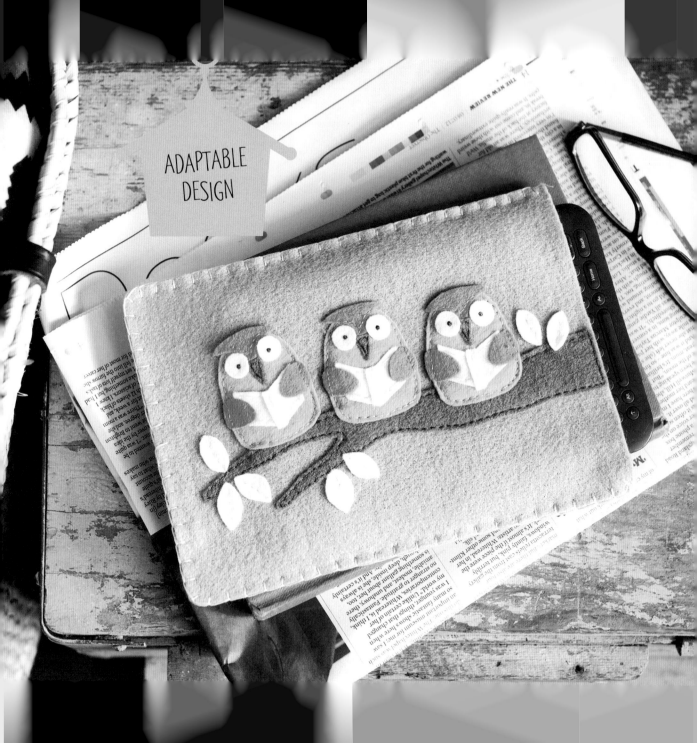

# HOW TO MAKE ... OWL KINDLE COVER

## MATERIALS

ONE PIECE OF LIGHT GRAY FELT MEASURING 6¼" x 9" (16 x 23 cm) FOR FRONT COVER

ONE PIECE OF DARK GRAY FELT MEASURING 6¼" x 9" (16 x 23 cm) FOR BACK COVER

FELT FOR APPLIQUÉ: STRIP OF DARK GRAY MEASURING 1½" x 8" (4 x 20 cm) PLUS SMALL PIECES OF WHITE, ORANGE AND YELLOW

EMBROIDERY FLOSS TO MATCH FELT COLORS

EMBROIDERY NEEDLE

SCISSORS

### TIP
You can easily alter the size of the front and back cover pieces to match your gadget, but do add ⅜" (1 cm) seam allowance for the blanket stitch edge.

01 Use the templates provided to cut out the required appliqué pieces as follows: from yellow felt – three owl bodies; from orange felt – three owl headpieces, three left wings and three right wings; from white felt – six eyes, three books, three spines, and seven leaves; from dark gray felt – three beaks. Cut the branch from the strip of dark gray felt.

02 Pin the branch onto the light gray front cover piece, positioning it approximately 2¼" (6 cm) from the bottom. Stitch all the way around using running stitch and working with one strand of embroidery floss in a matching color.

03 Now layer up the felt pieces for each owl appliqué. Position the spine on the book and stitch in place in the middle of the owl's body with running stitch and one strand of embroidery floss to match. Then add the wings, the beak, and the headpiece. Finally, add the white felt eyes using a French knot worked with three strands of dark gray embroidery floss for the pupils.

04 Once all three owls are complete, position them onto the branch, making sure sufficient space is left between them. Secure with running stitch using one strand of embroidery floss to match the owls' bodies. Stitch on the white leaves to complete the front design.

05 Place the front cover piece right side up onto the back cover piece, and use four strands of light gray embroidery floss to blanket stitch around the edges, leaving the right-hand side unstitched.

SEE PAGE 92 FOR TEMPLATES

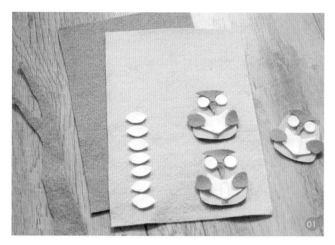

01

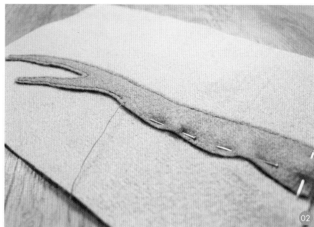

02

## CHARLIE MOORBY
### aka THE SAVVY CRAFTER

Charlie is a thrifty craft blogger and incurable stitching addict with a penchant for anything handmade. Commissioning Editor by day and crafter by night, you'll find her collecting buttons and hoarding ribbons on a daily basis.
She's a dab hand with a pencil and loves a spot of cross stitching too.
Find her online at thesavvycrafter.com

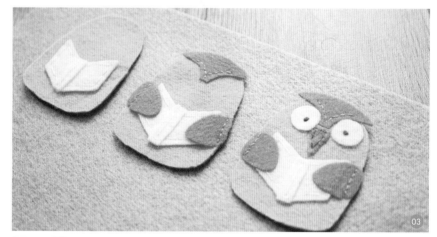

03

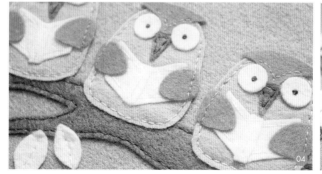

04

05

# 3D FELT
# FLYING PARROTS

THESE COLORFUL, HAND-STITCHED PARROTS ARE A QUIRKY AND EXOTIC TWIST ON THE TRADITIONAL FLYING DUCK ORNAMENTS. MADE FROM FELT AND GENTLY PADDED TO GIVE SOME DIMENSION, THE LARGEST HAS A WINGSPAN OF ABOUT 8" (20 CM) AND THE SMALLEST 5" (13 CM).

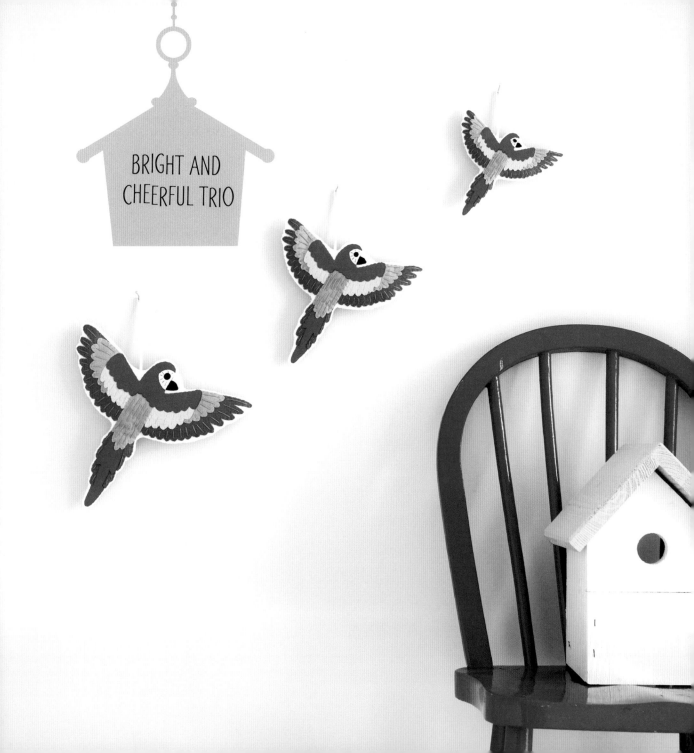

BRIGHT AND
CHEERFUL TRIO

# HOW TO MAKE ... FLYING PARROTS

## MATERIALS

FOUR SHEETS OF WHITE FELT MEASURING
9" x 12" (23 x 30.5 cm)

ONE SHEET OF BLUE FELT MEASURING
9" x 12" (23 x 30.5 cm)

ONE PIECE OF RED FELT MEASURING
6" x 6½" (15 x 16.5 cm)

ONE PIECE OF LIGHT BLUE FELT MEASURING
7" x 7½" (18 x 19 cm)

ONE PIECE OF YELLOW FELT MEASURING
5" x 5½" (12.5 x 14 cm)

SMALL PIECES OF BLACK AND CREAM FELT

SEWING THREAD: BLACK, CREAM, WHITE, RED,
YELLOW, BLUE, AND LIGHT BLUE

EMBROIDERY FLOSS: RED, YELLOW, BLUE, AND
LIGHT BLUE

NARROW WHITE RIBBON, ABOUT 24" (60 cm)

POLYESTER TOY STUFFING

SCISSORS, SEWING NEEDLE, AND PINS

01 Using the templates provided and following the enlargement advice given, make three sets of parrot templates – small, medium, and large. Cut out each piece from the color felt marked on the template page, and keep the felt pieces for each parrot size together. Repeat steps 2–8 to make each parrot.

02 Place the wing base on a white felt sheet, leaving room to add the head and tail feathers later. Pin, then sew around the edges with neat whip stitches using matching sewing thread. Arrange the two tail feather pieces and the back piece so they overlap slightly. Pin and sew as before with matching sewing thread.

03 Position wings A and B on the wing base, overlapping slightly, and then pin and sew. Place the head in position, and then pin and sew.

04 Sew the remaining small pieces (face, top beak, and bottom beak) in place. Cut out a small circle of black felt for the eye and use black sewing thread to sew in position. Sew a burst of single stitches radiating from the eye. Sew a line of black backstitches along the top of the beak.

05 Using embroidery floss in matching colors, mark out the parrot's feathers working with two strands for the small parrot, three strands for the medium parrot and four strands for the large parrot. Sew one long stitch to mark out each feather.

06 Cut out the parrot, leaving a narrow border of white felt around the design. Use the just-cut shape as a template to cut a matching backing piece from white felt.

07 Cut three lengths of ribbon: 6" (15 cm) for the small parrot, 7" (18 cm) for the medium parrot, and 8" (20 cm) for the large parrot. Fold the ribbon in half to form a loop and stitch the cut ends to the back of the parrot front using white sewing thread, so that when you hold the loop the parrot hangs at the desired angle (sew into the felt but not all the way through it).

08 Pin the front and back parrot pieces together and whip stitch around the edge with white sewing thread. Lightly stuff as you go; use a pencil to poke small pieces of stuffing into the points of the wings and tail for even padding. Finish your stitching neatly at the back.

## SEE PAGE 92 FOR TEMPLATES

### LAURA HOWARD aka LUPIN

Laura is a not-quite grown up girl who likes to make and do and is completely obsessed with felt. She shares free tutorials and writes about her crafty adventures on her blog bugsandfishes.blogspot.com and sells her work at lupinhandmade.com

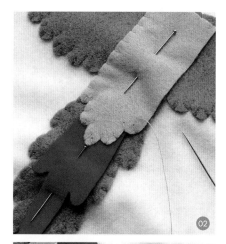

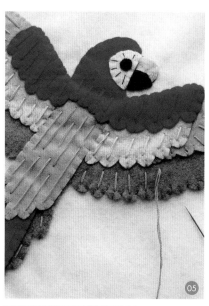

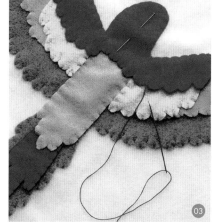

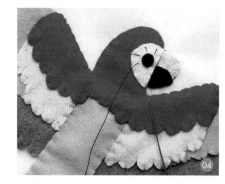

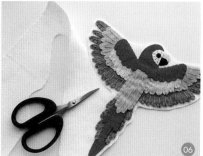

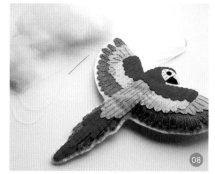

13

# NEEDLE FELT
# CHICKEN FAMILY

CHICKENS COME IN ALL SHAPES, SIZES, AND SHADES. THIS COLORFUL LITTLE FAMILY IS FUN AND QUICK TO MAKE — THE PROUD ROOSTER AND THE BROODY HENS EACH TAKE ABOUT 2–3 HOURS. BE INVENTIVE AND CREATE A WACKY HAIR-DO FOR YOUR ROOSTER AND USE UNUSUAL COLORS FOR YOUR OWN RARE BREEDS.

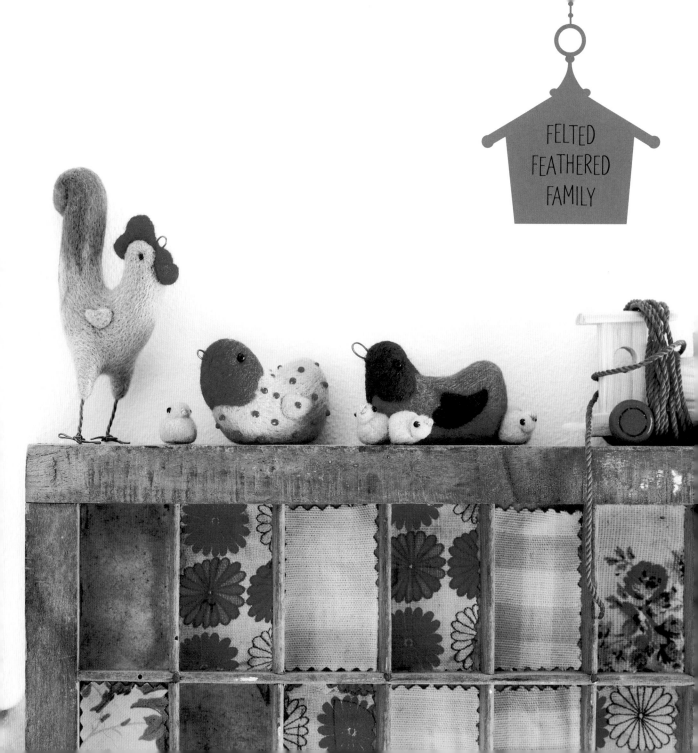

FELTED
FEATHERED
FAMILY

# HOW TO MAKE ... CHICKEN FAMILY

## MATERIALS

MERINO ROVING, SMALL AMOUNTS IN COLORS OF YOUR CHOOSING

SEED BEADS AND EMBROIDERY FLOSS

BEADING (LONG, THIN) NEEDLE

THIN WIRE FOR LEGS AND BEAK

TRIANGULAR FELTING NEEDLES AND HOLDER, TWO SIZE 40

FELTING MAT (SPONGE OR BRUSH)

SMALL VICE OR CRAFT GRIP

ROUND-NOSED PLIERS OR WIRE TWISTERS

### TIP

Choose the colors you prefer for the chickens' bodies, but shades of red wok best for the "combs", and wings and tails can be better defined with deeper or contrasting shades.

01 Take a 18" (46 cm) length of roving in your chosen body color, teased out to a strip about 2" (5 cm) wide. Work it into a loose crescent shape – longer and thinner for the rooster, plumper for the hens. Using two felting needles in your holder, gently stab the fiber to solidify the shape, adding bits of fiber where you want a little more plumpness.

02 Use one needle in your holder to shape the curl in the rooster's tail. Be sure to turn your bird as you work to keep a nice 3D shape.

03 For a nesting hen, shape the bottom of the bird so that it is flat. Use your thumb as a guide to make a firm edge so that she sits snugly. Once you are happy with the bird's shape, give it a gentle squeeze to see how dense the fiber is. If it feels firm and not too squishy, it's time to move on to make the beak and legs.

04 To make the beak, take a short length of wire ⅜"–¾" (1–2 cm) and bend it into a fish shape. Twist the ends together and trim.

05 Drill or pierce a little dent in the bird's head where the beak is to go. Tie a length of floss to the crossed ends of the wire, thread onto a long beading needle and take the needle into the dent, aiming it so that it comes out at the back of the head. Pull on the floss to take the wire ends inside the head.

06 Tie a knot in the floss to fasten the beak in place. Trim the ends, tucking any loose threads inside the body. Needle a wisp of fiber around the beak base to tidy it up.

07 To make the rooster's legs, cut three strands of wire about 5" (13 cm) long. Leaving ¾" (2 cm) of free wire at each end, hold the strands firmly in a small vice or craft grip and grasp the other end with pliers (or wire twisters). Turn the wire from the grip end, using the pliers to keep the strands steady and fixed.

08 Gently bend the twisted wire into a U shape. Use pliers to form the ends into four small claws, trimming off any excess.

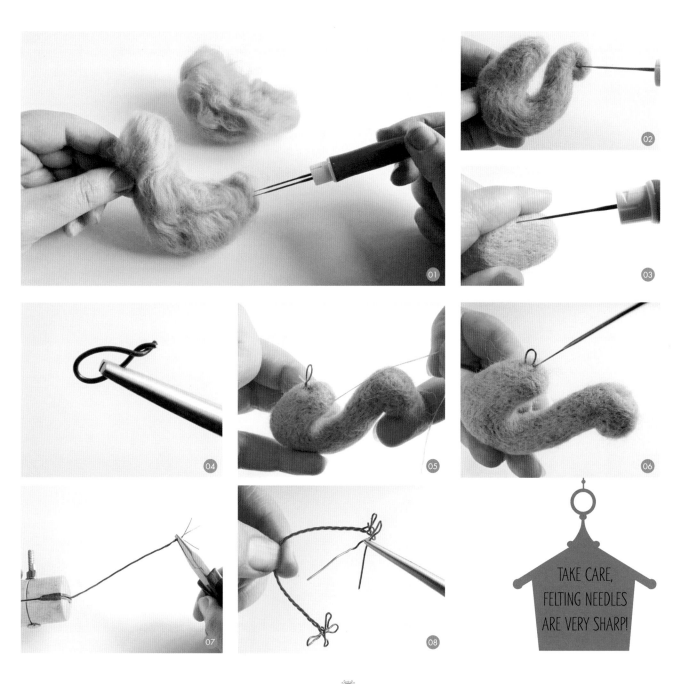

TAKE CARE,
FELTING NEEDLES
ARE VERY SHARP!

# HOW TO MAKE ... CHICKEN FAMILY (CONTINUED)

09 Make a cut in the rooster's tummy, insert legs and work more fiber over the cut to hold them firmly in place.

10 Wind and needle felt a small length of roving around the top of the legs to give the rooster full thighs.

11 To get a smooth, even finish to your birds, take wisps of roving teased out to make a thin veil. Ensure the strands are lying in the same direction as the body line and carefully cover the body, working your jabs very closely. Add a cover of darker wool to the rooster's tail, using your needle to drag the roving into smooth lines.

12 Needle felt the wings and wattles directly onto the body, using one needle for finer detailing.

13 To attach black seed beads for eyes, use a long beading needle to take a doubled-up piece of floss through the sides of the face and thread a seed bead on each side.

14 Going back into first one eye socket, then the other, bring the threads out at the back of the neck in the same place. Tighten the threads to fix the eyes firmly in place and tie together with a secure knot. Bring the threads out further down the body before snipping off.

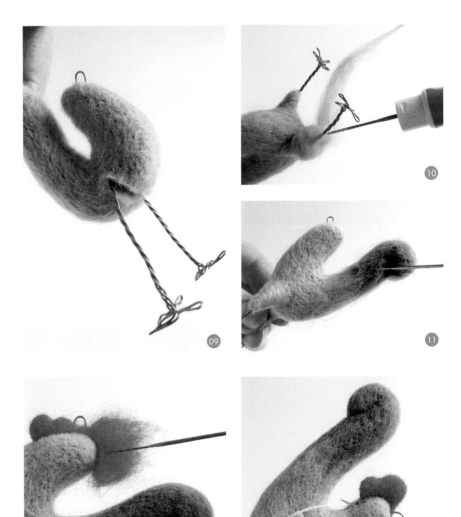

15 To make the chicks, take very small amounts of yellow roving and form a loose ball, before anchoring them onto the mother and shaping into pea-sized birds, adding tiny heads. Sew French knots for their beaks and use tiny seed beads for their eyes.

16 You can add extra decoration to your chickens using embroidery stitches and beads. Herringbone stitch makes a great alternative to a needle felted wing, for example.

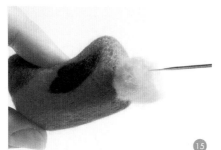

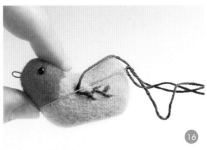

## GRETEL PARKER

Children's illustrator Gretel Parker discovered needle felting five years ago. Now her work is collected all over the world and she enjoys passing on her knowledge and spreading the needle felting "bug" to new crafters.
www.gretelparker.com

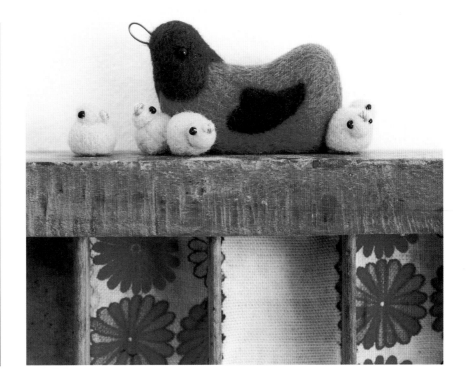

## PAPER CUT

# BIRD GREETING

THERE ARE TWO SPECIAL BIRD DESIGNS TO HONE YOUR PAPER CUTTING SKILLS. THE CRANE REPRESENTS GOOD FORTUNE, AND AN ANCIENT JAPANESE LEGEND HAS IT THAT ANYONE WHO FOLDS A THOUSAND PAPER CRANES WILL BE GRANTED THEIR WISH. THE LUCKY KINGFISHER IS SAID TO PROTECT FISHERMEN FROM STORMS AT SEA.

GOOD
FORTUNE
CARDS

# HOW TO MAKE ... BIRD GREETING

SEE PAGE 93 FOR TEMPLATES

## MATERIALS (PER CARD)

ONE PIECE OF THIN WHITE CARD MEASURING 12" x 6" (30 x 15 CM)

ONE PIECE OF COLORED PAPER MEASURING 5¾" x 6" (14.5 x 15 CM)

RULER AND SCORING TOOL

PENCILS, H AND 2H

TRACING PAPER

CRAFT KNIFE AND CUTTING MAT

GLUE AND ADHESIVE TAPE

SOFT ERASER

SMALL HOLE PUNCH (FOR CRANE DESIGN)

### TIP

A thick cartridge paper will work just as well as white card. You'll need a soft eraser for removing pencil lines, and a soft brush, though not essential, is useful too.

01 Take the white card and, working from the inside, mark a ¾" (2 cm) border in pencil on the left-hand side. Use the softer pencil to trace off your chosen bird template. Turn the tracing paper over and lay it down on the card, aligning the edges of the square to the pencil-marked border. Attach a piece of adhesive tape to each corner to keep the tracing in place, then use the harder 2H pencil to go over the design, transferring it to the card.

02 Working on a cutting mat, cut out the design with a craft knife. Keep referring to the finished card photo to make sure you are cutting the right bits. Work slowly and carefully (make sure the blade is sharp and keep your fingers clear). If you make a mistake simply incorporate it into the design.

03 To make a perfect circle for the crane's eye, turn the card over to the right side and cut with a small single hole punch. Then turn the card back over ready to attach the color insert.

04 Glue your piece of colored paper to the inside right-hand side of the card, aligning the paper edges to the card edges. Score down the center of the card and fold in half.

05 Open the card once again and use a soft eraser to carefully rub out any remaining pencil lines. Be careful not to tear the paper cut and use a soft brush, if you have one, to sweep away the bits of eraser. Fold in half to complete the card.

### CLARE YOUNGS

Designer-maker Clare was given a craft book with a pile of paper and fabric at the age of eight and she hasn't stopped making since! Having trained as a graphic designer, she worked in packaging and illustration until turning to craft full time five years ago. Clare has written several craft books – to find out more visit www.youngs-studio.com

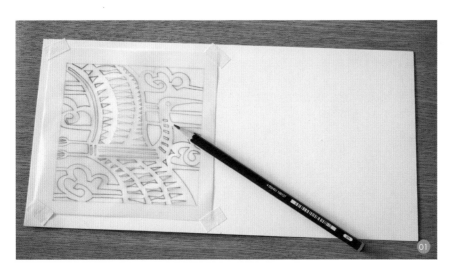

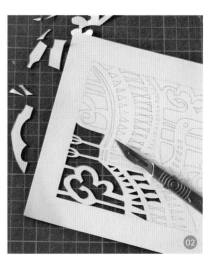

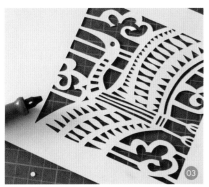

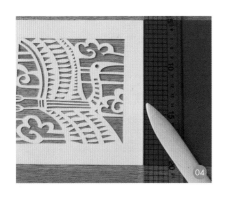

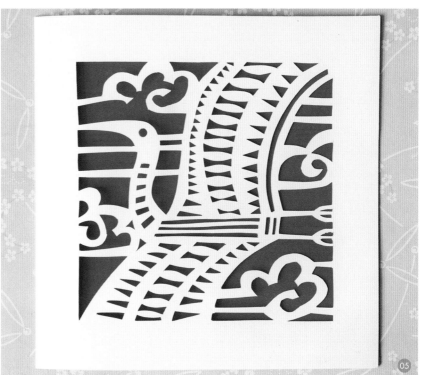

# CROSS STITCH ON CANVAS
# LOVING LOVEBIRDS

THIS BEAUTIFUL DESIGN IS WORKED WITH TAPESTRY YARN ON AN OPEN-WEAVE CANVAS USING CROSS STITCH. THIS SIMPLE STITCH IS EXPLAINED ON p90 AND AN EASY-TO-FOLLOW COLOR CHART IS PROVIDED ON p95. THE FINISHED EMBROIDERY MEASURES ABOUT 20" (50 cm) IN DIAMETER AND HAS BEEN MADE INTO A DEEP FLOOR CUSHION.

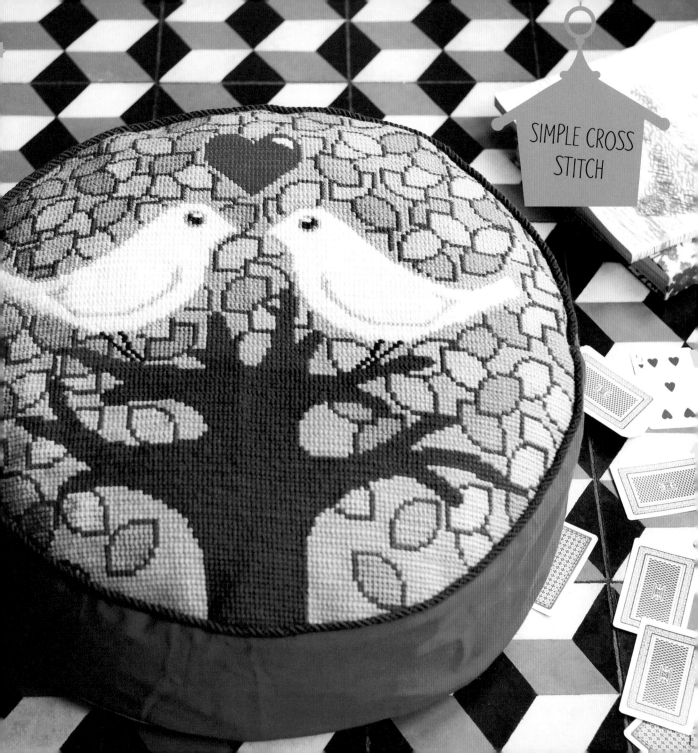

SIMPLE CROSS
STITCH

# HOW TO MAKE ... LOVING LOVEBIRDS

SEE PAGE 95 FOR CHART

## MATERIALS

ONE PIECE OF 7HPI ZWEIGART MONO INTERLOCK CANVAS MEASURING 30" x 30" (75 x 75CM)

APPLETON BROS TAPESTRY YARN: THREE HANKS OF HONEYSUCKLE YELLOW #698; TWO HANKS OF KINGFISHER #481; ONE HANK EACH OF WHITE #991, GRASS GREEN #251A, GRASS GREEN #254, DRAB GREEN #331, DULL GOLD #855, AND HERALDIC GOLD #844; ONE SKEIN EACH OF BRIGHT ROSE PINK #946 AND CHOCOLATE BROWN #187

ONE PIECE OF WHITE MEDIUM-WEIGHT COTTON FABRIC MEASURING ABOUT 24" x 24" (60 x 60 CM)

TWO PIECES OF RED MEDIUM-WEIGHT COTTON FABRIC MEASURING 32½" x 7" (83 x 18 CM)

ZIPPER, 20" (50 CM)

BROWN PIPING, 63" (160 CM)

CUSHION PAD, 20" (50 CM) DIAMETER AND 6" (15 CM) DEEP

TAPESTRY NEEDLE SIZE 18 AND SEWING NEEDLE

01 Find the center of your canvas by folding it in half horizontally and then vertically. These fold lines correspond to the arrows marked at the side of the chart (indicating the chart center) and will ensure that you work your design centrally on the canvas.

02 Each square on the chart represents one cross stitch; the color of the square indicates the wool color (see chart key). Following the chart, stitch the design using one strand of tapestry yarn in your needle (see Working the Stitches, p90). You may find it easier to work the tree and leaf outlines first before filling in the background and leaf colors.

03 When you have completed the stitching, trim the canvas with a surplus of ⅝" (1.5 cm) all around.

04 To make the cushion back, draw and cut out a 20" (50 cm) circle of brown paper; fold in half and cut in two to give a semicircular pattern. Fold the white fabric in half and tape or pin the pattern to it, aligning the straight side with the fabric grain. Allowing for a ⅝" (1.5 cm) seam allowance, cut around the paper pattern.

05 Pin the fabric pieces right sides together and stitch ¾" (2 cm) only at each end of the straight edge. Baste the remaining length together and press the seam open. Place the zipper face down along the seam allowance and machine stitch in place using a zipper foot. Remove the basting stitches.

06 Place the red fabric pieces right sides together and pin and stitch along the short ends to form a continuous strip. With right sides together, pin one long edge of the fabric strip to the canvas, clipping within the ⅝" (1.5 cm) seam allowance if necessary to manipulate around the curve. Stitch in place leaving a small gap for the ends of the piping (see step 7).

07 With right sides together, pin the white fabric to the other side of the strip and stitch all the way around. Turn inside out through the zipper opening. Press lightly through a clean damp cloth if necessary. Slip stitch the piping around the top edge of the cover and insert the ends through the gap in your stitching; secure with a couple of stitches. Insert cushion pad to finish.

 02

TIP
To make it easier to follow the design, you can outline key areas onto the canvas with a permanent marker.

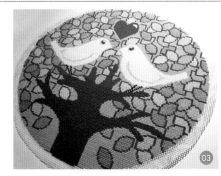
 03

 04

## EMILY PEACOCK

Emily Peacock is a needlework designer who sells her trademark eye-catching needlepoint kits on her website www.emilypeacock.com as well as in Liberty of London. More of her designs can be found in her book, *Adventures in Needlework*.

06

# PITTER PATTER PURSE

GET TO GRIPS WITH INTARSIA TO MAKE THE DANCING BIRD MOTIFS ON THIS BAG. AS THE BAG IS FELTED IN THE WASHING MACHINE, YOU WON'T HAVE TO ADD A LINING. THE FINISHED SIZE IS 8" (20 CM) ALONG THE BOTTOM SEAM AND 8" (20 CM) UP TO THE CURVE OF THE HANDLE, SO IT FITS PERFECTLY OVER THE SHOULDER.

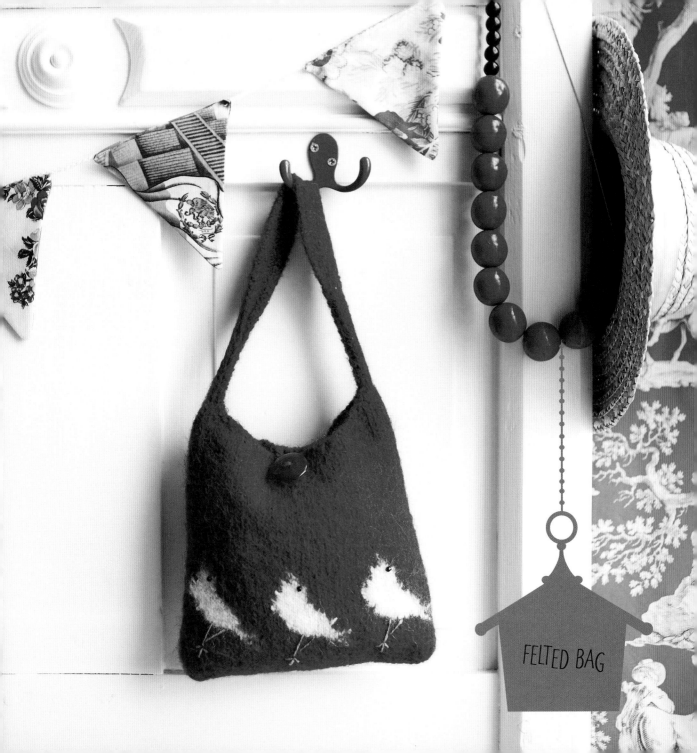

FELTED BAG

# HOW TO MAKE ... PITTER PATTER PURSE

## MATERIALS

100G BALLS (220 YARDS/200 METERS) OF ROWAN CREATIVE FOCUS WORSTED, ONE EACH IN CARMINE #2055 (A), ECRU #0100 (B), AND SAFFRON #3810 (C), OR SIMILAR YARN (WORSTED-WEIGHT WOOL AND ALPACA BLEND – YARN SUITABLE FOR FELTING)

SMALL AMOUNT OF YELLOW YARN TO EMBROIDER THE BIRDS' LEGS AND FEET

THREE BLACK SEED BEADS FOR EYES

ONE 1¼" (3 CM) MATCHING BUTTON FOR CLOSURE

KNITTING NEEDLES, ONE PAIR OF SIZE 7 (4.5 MM), PLUS THIRD NEEDLE IN SAME SIZE FOR BINDING OFF

TAPESTRY NEEDLE

COTTON YARN

SEWING NEEDLE AND THREAD

## GAUGE TIP
20 sts and 24 rows to 4" (10 cm) square over St st before felting. Finished size 9½" x 10" (24 x 25 cm) before felting, 8" x 8" (20 x 20 cm) after.

01 Preparing the wrappings.
The bird motifs on the front panel of the bag are created using the intarsia colorwork technique. With this technique, you use separate lengths of yarn for each color area when working across a row, reading the color sequence from a chart. Before you can start knitting your intarsia pattern, you need to make small "wrappings" or "bobbins", in each required color; this is simply a short length of yarn. This makes the design easier to work; working with whole balls of yarn will quickly make a jumbled mass of yarn that will be difficult to detangle later.

02 Working from the chart.
On the chart (see opposite page), each square represents one stitch, while each horizontal line represents one row. The chart is read from the bottom right-hand corner, with the knit (right-side) rows running from right to left and the purl (wrong-side) rows running from left to right. The yarn used to create the bird motifs is represented with its own color.

03 Make the front panel of the bag.
Using size 7 needles and yarn A, cast on 47 sts. Starting with a knit row, work 10 rows in St st.

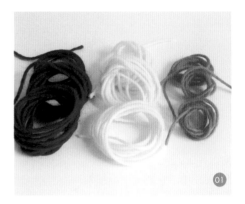

01

## Substituting Yarns

If you want to substitute the suggested yarn, you will need to use an alternative yarn that will felt (one that will shrink when washed at a high temperature in a washing machine and form a denser material). Wool yarns will usually felt, as will some blends of wool with other natural fibers such as alpaca. However, some wool yarns are specially treated to make them machine-washable, and these will not felt; check the ball band. It is a good idea to test your yarn before felting the finished piece, so once you have made and measured your gauge swatch, try felting that.

You will need to break off three lengths of yarns A, B, and C from the main balls. Use these short lengths (the wrappings or bobbins) to work the intarsia pattern (see step 1). Working the chart from right to left and from row 1 (see step 2), place the motifs as follows on the next row. Keep using the main ball of yarn A for the next 3 rows.

**Row 1 (RS):** *K1, join in yarn B on the next st as follows: insert your needle into the next st, bring up the wrapping and place over the yarn you will be using for the next st, then work the st as you would normally, knit row 1 of chart, rep from * twice more, k2.

**Row 2 (WS):** P2, *purl row 2 of chart, p2, rep from * twice more.

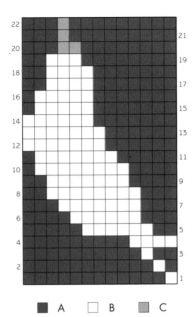

■ A   □ B   ■ C

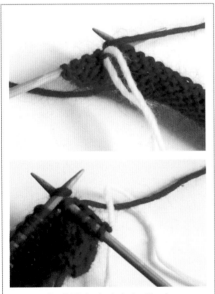

Row 1: Join in color, back view (above) and front view (below)

02

**Row 3:** K2, *knit row 3 of chart, k2, rep from * twice more.
On the next row you will need to join in the separate length of yarn A to work in between the bird motifs. Use the same method set out above, joining in the wrapping before you need to use it.

**Row 4:** K2 from main ball, *work row 4 of chart, k2, rep from * to end. Keep working from chart until all rows are completed. When changing colors you will need to twist the two yarns by holding one over the top of the other (see Changing Colors).
Cont working in St st for a further 29 rows.

# Changing Colors

When knitting an intarsia motif, it is important to twist the two yarns together when changing color, otherwise you will leave a big hole in the knitted fabric. The yarns must be twisted over each other to link them together and prevent a hole from forming between the colors. Always cross the yarns on the wrong side of the work.

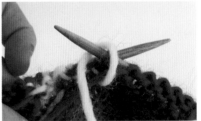

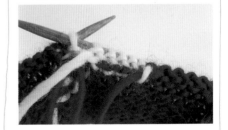

04 Shape top.

K14, bind off 19 sts, k to end.

Work on first set of 14 sts only as follows:

Knit to end, turn, then bind off 4 sts at beg of next row, purl to end. (10 sts)

**Next row:** Knit until there are 3 sts on LHN, k2tog, k1. (9 sts)

Bind off 3 sts at beg of next row, purl to end. (6 sts)

**Next row:** Knit until there are 3 sts on LHN, k2tog, k1. (5 sts)

Work 3 rows in St st starting with a purl row.

Slip rem sts onto spare needle or stitch holder – do not bind off.

Rejoin yarn to 14 sts on needle and work shaping to match other side.

05 Make the back panel.

Using size 7 needles and yarn A, pick up and knit 47 sts along the cast-on edge of the front panel.

**Row 1 (WS):** Knit.

Then work as given for front panel.

06 Sew up side seams and make handle.

Sew up the side seams to join the front and back panels.

You should now have 2 sets of 10 sts to make the handle.

With RS facing, slip 10 sts onto size 7 needle, k3, k2togtbl, k2tog, k to end. (8 sts)

**Next row:** K2, p4, k2.

**Next row:** Knit.

Rep last 2 rows until about 50 rows have been worked.

Do not bind off – slip sts onto holder.

Rep for other side of handle.

Hold both sets of 8 sts together with RS facing, then bind off using three-needle method.

Weave in ends.

07 Prepare for felting.

Using cotton-based yarn (which will not felt/shrink), work a running stitch along the top opening of the bag. This helps the bag keep its shape. Repeat this process for the handle by folding the handle in half and stitching the sides together from the fold down, leaving about 4" (10 cm) open toward the bag.

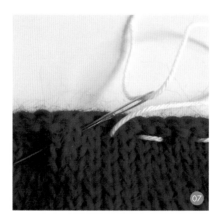

08 Felting the bag.

Put bag into washing machine along with an old pair of jeans or similar hard-wearing fabric (don't use towels – the soft fibers can transfer onto the knitted fabric and make it bobbled). Wash at a high temperature – try 140°F, but as this can vary from machine to machine, felt your gauge swatch first to see what temperature works. Block the felted bag to the finished size and leave to dry.

## CAROL MELDRUM

Carol is a textile designer, author and workshop tutor based in Glasgow, U.K. who enjoys nothing better than playing around with yarn, coming up with new ideas and sharing them with folk at www.beatknit.com and blog.beatknit.com

09 Adding the embellishments.
Once the bag has frinished drying completely, remove the running stitch yarn from the top opening. Sew a black seed bead onto each bird's face for a bright beady eye, then use the yellow yarn to embroider the birds' legs and feet.

10 Make the bag closure.
Make a button loop about 3¼" (8 cm) long, fold in half, and stitch to the inside of the bag. (The loop was made from crochet chain, but you could also create the loop from twisted cord, or a piece of matching ribbon.) Sew the button onto the front of the other side to match the loop.

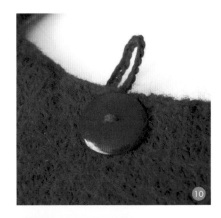

# Abbreviations

**beg:** beginning
**cont:** continue
**k:** knit
**k2tog:** knit two stitches together
**k2togtbl:** knit two stitches together through the back loops
**LHN:** left-hand needle
**p:** purl
**rem:** remaining
**rep:** repeat
**RS:** right side
**st(s):** stitch(es)
**St st:** stockinette stitch
**WS:** wrong side

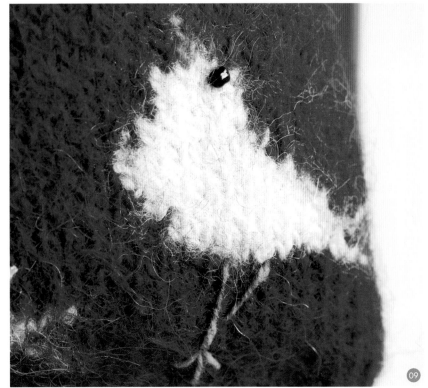

# FEATHERED INSPIRATIONS

HOME BIRDS

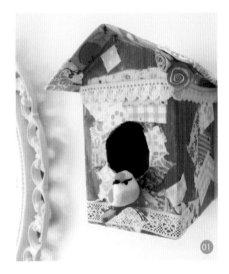

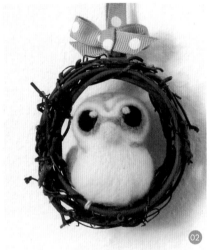

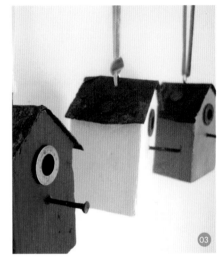

## 01

If you would like to make a sweet little home for your bird creations Jane from littleteawagon has come up with a nifty way to transform mini cereal boxes and paper and fabric scraps into the perfect birdie home. For more, see her fabulous fabric birdhouse tutorial at teawagontales.blogspot.co.uk

## 02

Melanie Ann Green is a talented designer who, as her alter ego Feltmeupdesigns, creates flocks of needle felted birds. She likes to find interesting perches for her finished creations, and this little twig wreath, so reminiscent of a bird's nest, makes the perfect home for her little barn owl. www.feltmeupdesigns.co.uk

## 03

If you are looking for an alternative to Easter egg hanging decorations you could follow Cornish designer Kirsty Elson's example. She has made these birdhouse ornaments from small pieces of driftwood, and creating beautiful pieces from found objects is her favorite thing. www.kirstyelsondesigns.co.uk

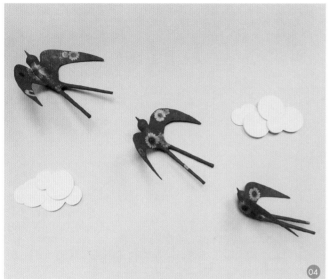

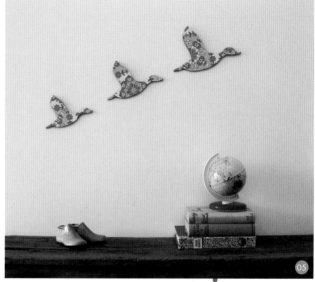

## 04

This set of three fuchsia pink flying swallows is designed and made by Jaina Minton of Polka Dot Sundays, who wanted to create a twist on the traditional flying ducks. She sculpts them from newspaper and card, adding pink paper and pressed flower imagery decoupage. Jaina lists her creative obsessions as paper, color, and objects that make you smile. www.polkadotsundays.com

## 05

Delilah Devine is the creative playground of Australian textile designer and illustrator Linda Marek. Linda is an avid collector of vintage wallpaper and fabrics and she has cupboards full to inspire pieces such as these flying duck wall plaques – her creative reinvention of a retro classic. For more about Linda's eco-friendly designs visit www.delilahdevine.com

LIFE ON THE WING

# FELT EMBROIDERED
# BIRDIE SEWING SET

KEEP YOUR PINS AND NEEDLES FROM FLYING AWAY WITH THIS SWEET LITTLE SEWING SET – A PINCUSHION WITH A LITTLE BIRD PERCHED ON A SPOOL OF THREAD AND A POCKET-SIZE NEEDLECASE. FROM A FEW SQUARES OF PRETTY, CONTRASTING FELT AND SIMPLE EXTRAS, YOU CAN STITCH THESE UP IN NO TIME AT ALL.

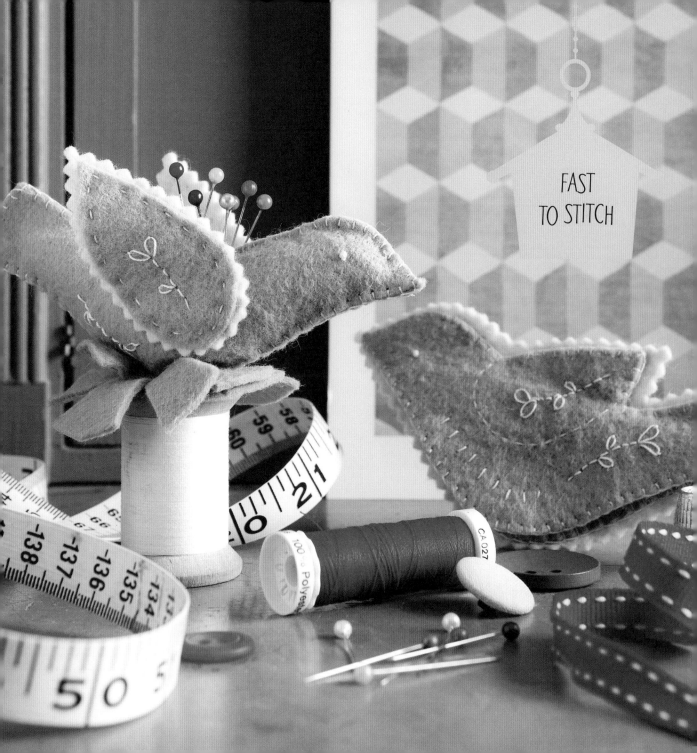

FAST
TO STITCH

# HOW TO MAKE ... BIRDIE SEWING SET

SEE PAGE 93 FOR TEMPLATE

## MATERIALS

GREEN FELT: TWO PIECES MEASURING 4" x 6" (10 x 15 cm) AND ONE PIECE MEASURING 3" x 3" (7.5 x 7.5 cm)

WHITE FELT: THREE PIECES MEASURING 4" x 6" (10 x 15 cm) AND ONE PIECE MEASURING 6" x 6" (15 x 15 cm)

THREE PIECES OF BLUE FELT MEASURING 4" x 6" (10 x 15 cm)

WHITE EMBROIDERY FLOSS

SMALL AMOUNT OF POLYESTER TOY STUFFING

WOOD THREAD SPOOL ABOUT 2" (5 cm) TALL

WATER-ERASABLE FABRIC PEN (OPTIONAL)

SEWING NEEDLE AND PINS

SCISSORS AND PINKING SHEARS

WHITE GLUE

01 For the needlecase, make a template of the whole bird/wing design and use to cut two birds from the larger pieces of green felt. Cut a third bird from the same size piece of white felt using pinking shears to make it slightly larger than the green birds.

02 Embroider one of the green bird shapes for the needlecase front. Use two or three strands of embroidery floss and running stitch to define the wing shape. Decorate the wing and the tail, adding some lazy daisy stitch detailing. Work a French knot for the eye and single straight stitches for the belly. Use blanket stitch to neatly finish along the bottom edge and the tail end.

03 Place the second green bird beneath the embroidered bird and blanket stitch together along the top edge only. Place the partially joined green bird onto the pinked (white) bird shape. Blindstitch the bottom green bird layer to the pinked backing.

04 To make the needlecase insert, place a piece of paper inside the bird, trace the shape, and cut out.

05 Fold the white felt square in half. Pin the straight edge of the paper insert exactly on the folded edge and cut around the shape. Put the felt insert in the bird and blindstitch in place.

06 To make the pincushion, cut separate bird and wing templates. Cut two bird shapes from two pieces of blue felt, and two wings from the remaining piece. Cut two larger wings from the remaining piece of white felt using pinking shears.

07 Embroider the two blue bird shapes, keeping in mind that one will be used for the front and the other for the back. Place front and back together, wrong sides facing and use blanket stitch to join from the beak to beyond the tail end. Stop sewing (do not cut working thread) and begin to fill lightly, using a pencil to push the stuffing into the tail. Continue to stitch, filling as you go.

08 Stitch the embroidery details onto the blue wings. Stitch each embroidered wing to the pinked (white) wing backs. Stitch the wings to each side of the bird, working along the bottom edges only.

# CHARLOTTE LYONS

Inspired by the humble simplicity of traditional crafting, Charlotte designs and makes things to love. Her fabric collections, stitch-able embroidery samplers and how-to's are featured online at charlottelyons.com and housewrenstudio.typepad.com

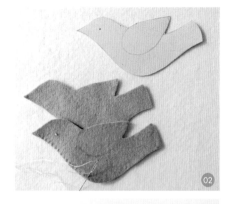

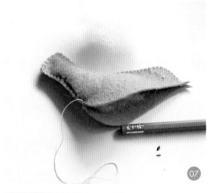

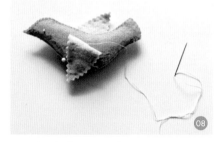

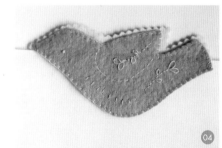

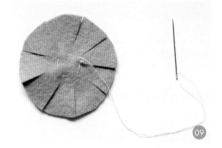

09 Cut a 2½" (6.5 cm) diameter circle from the green felt square. Snip toward the center to make eight or nine petals. In the center, work a circle of loose stitches (do not unthread the needle).

10 Gather the circle of stitches to create a cupped flower. Put the bird inside and stitch securely. Apply a little white glue to the flower base and place on top of the thread spool. Allow to dry.

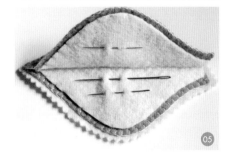

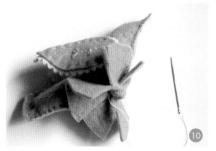

## CUTE CROCHET
# PENGUIN PILLOW

THIS LITTLE PENGUIN PILLOWCASE COULD BE MADE FOR A CHILD'S NIGHT-TIME COMPANION, OR TO ADD A CUTE BUT STYLISH TOUCH TO AN ADULT'S BEDROOM. IT MEASURES 12" x 12½" (30 x 32 cm) AND THE BASIC RECTANGLE SHAPE IS SIMPLE TO MAKE IN DOUBLE CROCHET.

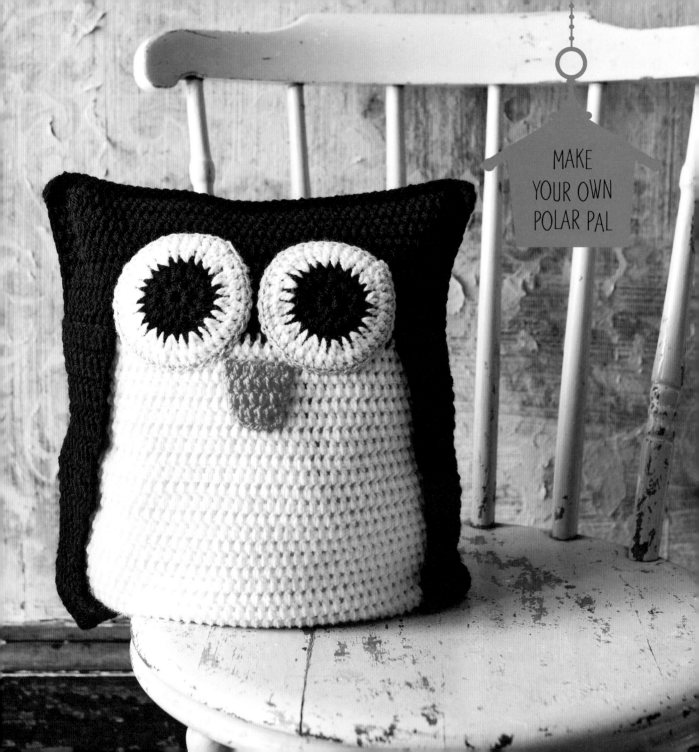

MAKE
YOUR OWN
POLAR PAL

# HOW TO MAKE ... PENGUIN PILLOW

## MATERIALS

50ɢ BALLS (145 YARDS/133 METERS) OF
ANNELL RAPIDO, ONE IN WHITE #3260 (A),
TWO IN BLACK #3259 (B), ONE EACH IN LIGHT
BLUE #3242 (C) AND ORANGE #3221 (D), OR
SIMILAR YARN (DK-WEIGHT ACRYLIC)

CROCHET HOOK, SIZE G6 (4 ᴍᴍ)

SEWING NEEDLE

SEWING THREAD: ORANGE AND GRAY

CUSHION PAD OR SMALL PILLOW TO FIT

## TIP

If you are making the pillow for a
child, use a hard-wearing yarn that
washes easily. Acrylic is ideal, and
very reasonably priced, but cotton
and synthetic blends and some wool
yarns will also work – check the yarn
ball band for washing instructions.

01 Make the penguin's front.
Using G6 crochet hook and
yarn A, ch53.
**Row 1:** 1dc in 4th ch from hook,
1dc in each ch across, turn. (50dc)
**Rows 2–26:** Ch3 (counts as 1dc),
1dc in each dc, turn.
**Row 27:** Break yarn A and join yarn
B; ch3 (counts as 1dc), 1dc in each
dc, turn.
Cont for further 11 rows or until front
measures 12½" (32 cm).
Fasten off and weave in ends.

02 Make the penguin's back.
Make as front, using yarn B only.

03 Make the eyes (make 2).
Using G6 crochet hook and
yarn B, ch4 and join with sl st to
make the foundation ring.
**Round 1:** Ch3, then work 11dc into
the ring. Sl st in 3rd ch of initial ch3
to join the round. (12dc)
**Round 2:** Ch3, 1dc in the same
point, *2dc in next st, rep from * to
end. Sl st to join the round. Break
yarn B and join yarn A. (24dc)
**Round 3:** Ch3, 1dc in the same
point, *1dc in next st, 2dc in next
st, rep from * to end. Sl st to join the
round. (36dc)
**Round 4:** Ch2, *1hdc in next st, rep
from * to end. Sl st to join the round.

Break yarn B and join
yarn C. (36hdc)
**Round 5:** 1sl st, *work 1sl st in
next st, rep from * to end. Sl st to join
the round.
Fasten off and weave in ends.

04 Make the beak.
Using G6 crochet hook and
yarn D, ch12.
**Row 1:** 1dc in 4th ch from hook,

### ILARIA CHIARATTI

Italian-born Ilaria lives in
the Netherlands with her husband.
She works as a freelance
photographer for interiors and runs her
own company, IDA Interior LifeStyle,
an interior design consultancy. She
shares her interior styling inspirations
and her crochet work on her blog at
www.idainteriorlifestyle.com.

1dc in each ch across, turn. (9dc)
**Row 2:** Sl st in first dc, ch3 (counts as 1dc), 1dc in next 6dc, turn. (7dc)
**Row 3:** Sl st in first dc, ch3 (counts as 1dc), 1dc in next 5dc, turn. (6dc)
**Row 4:** Sl st in first dc, ch3 (counts as 1dc), 1dc in next 4dc. (5dc)
Fasten off and weave in ends.

05 Make the wings (make 2).
Using G6 crochet hook and yarn B, ch13.
**Row 1:** 1dc in 4th ch from hook, 1dc in each ch across, turn. (10dc)
**Rows 2–9:** Ch3 (counts as 1dc), 1dc in each dc, turn. (10dc)
**Row 10:** Sl st in first dc, ch3 (counts as 1dc), 1dc in next 8dc, turn. (9dc)
**Rows 11–13:** Ch3 (counts as 1dc),

1dc in each dc, turn. (9dc)
**Row 14:** Sl st in first dc, ch3 (counts as 1dc), 1dc in next 7dc, turn. (8dc)
**Rows 15–25:** Ch3 (counts as 1dc), 1dc in each dc, turn. (8dc)

06 Making up the penguin's face. Place the eyes and beak of the penguin on the front of the cushion and sew in place.

07 Making up the penguin's body. Place the wings at the each side of the front; slip stitch to the front using the crochet hook and yarn B. Join front and back pieces of the penguin together by slip stitching the two side seams and the top seam. Insert the cushion pad and then sew up the bottom seam.

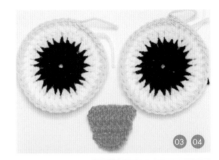

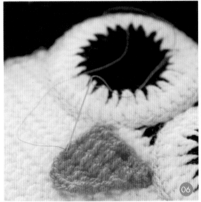

## Abbreviations

**(US terms used throughout)**
**ch:** chain
**cont:** continue
**dc:** double crochet
**hdc:** half double crochet
**rep:** repeat
**sl st:** slip(ped) stitch
US/UK differences:
US hdc (half double crochet) = UK htr (half treble crochet)
US dc (double crochet) = UK tr (treble crochet)

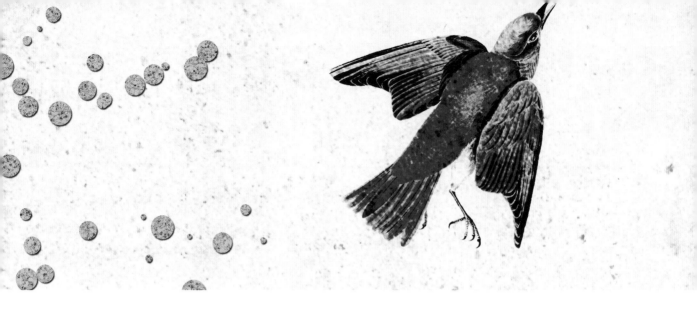

## RETRO-FABRIC

# BIRD CUSHION

THIS PROJECT IS A GREAT WAY TO GIVE NEW LIFE TO FAVORITE RETRO-PRINT FABRICS. USING BASIC MACHINE AND HAND-SEWING TECHNIQUES, YOU CAN CREATE YOUR VERY OWN BIRDIE TO KEEP YOU COMPANY AS YOU CRAFT. THIS CHICK MEASURES ABOUT 11" (28 CM) WIDE BY 13" (33 CM) HIGH.

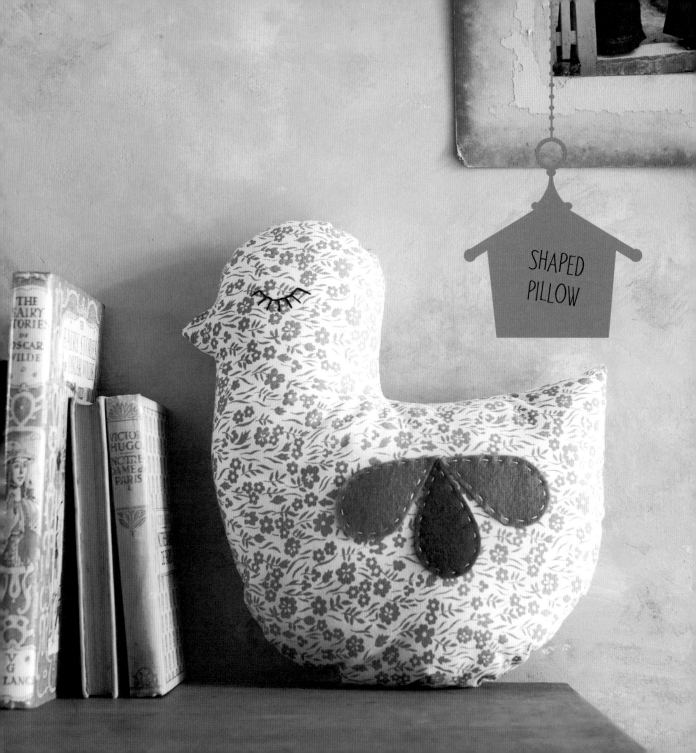

SHAPED PILLOW

# HOW TO MAKE ... BIRD CUSHION

01 Use the templates to cut out two bird shapes from your fabric (making sure one is reversed) and six teardrop shapes for the wings from felt (two in one color and four in the other color).

02 Pin the wings into position on each of the fabric pieces. Using two strands of embroidery floss and running stitch, sew on the wings.

03 Trace the eyes onto the right side of each bird shape using a water-erasable pen. Use three strands of embroidery floss and backstitch to stitch the eyes. Once finished, gently dab with a damp cloth to remove the pen marks.

04 Align the bird pieces right sides together, and pin. Stitch about ⅜" (1 cm) from the edge, leaving a 4" (10 cm) gap at the bottom.

05 Diagonally trim the corners at the beak and the tail, taking care not to cut too close to the stitching. Turn your bird the right way out through the opening, and use a knitting needle or other blunt-pointed tool to push out the corners. Be careful not to poke through the fabric.

06 Fill your bird with polyester stuffing until even and plump. Pay special attention to the beak and tail, pushing stuffing into the corners.

07 Fold over the edges of the opening and sew closed with overcast stitch. To finish, give the bird a light iron on a medium heat.

## CLARE NICOLSON

Clare founded her interior textiles and accessories line in 2004. A lover and collector of all things vintage, she has an ever-expanding fabric collection. Clare is always creating, whether for a new collection or just for fun, and she's never far away from her sewing machine. Find her online at www.clarenicolson.com

## TIP

Scale the bird down and fill with dried lavender instead of stuffing for a sweet-smelling gift.

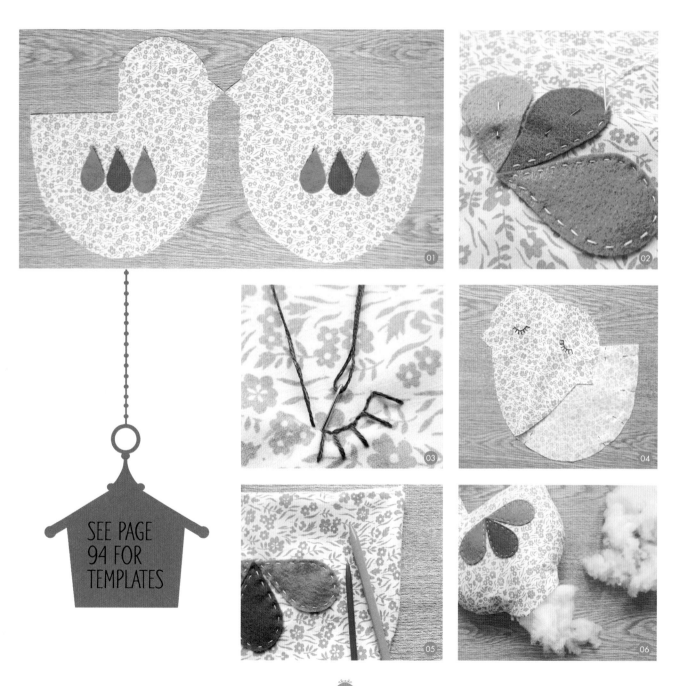

SEE PAGE
94 FOR
TEMPLATES

# EMBROIDERED BIRDHOUSE
# HOME TWEET HOME

STITCH UP THIS SWEET LITTLE BIRDHOUSE ORNAMENT TO HANG IN YOUR PORCH OR ABOVE YOUR FRONT DOOR TO WELCOME FAMILY AND FRIENDS TO YOUR HOME. IT IS MADE WITH EMBROIDERED FABRIC MOTIFS, SUCH AS THE ADORABLE HOUSE-PROUD BIRD AND BLOOMING FLOWER BOX, LAYERED ONTO FELT.

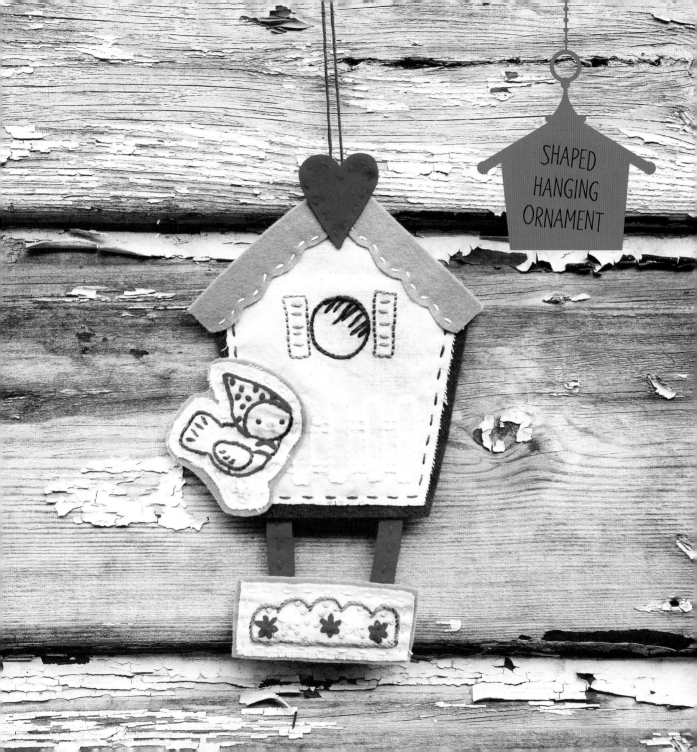

SHAPED
HANGING
ORNAMENT

# HOW TO MAKE ... HOME TWEET HOME

SEE PAGE 93 FOR TEMPLATES

## MATERIALS

ONE PIECE OF LIGHT-COLORED COTTON FABRIC MEASURING 6" x 8" (15 x 20 CM)

ONE PIECE OF BROWN FELT MEASURING 3½" x 4¼" (9 x 11 CM)

ONE PIECE OF LIGHT BLUE FELT MEASURING 4" x 3½" (10 x 9 CM)

ONE PIECE OF RED FELT MEASURING 2" x 1½" (5 x 4 CM)

EMBROIDERY FLOSS: BROWN, GREEN, YELLOW, RED, AND WHITE

WATER-ERASABLE FABRIC PEN

EMBROIDERY HOOP AND EMBROIDERY NEEDLE

SCISSORS AND PINS

**TIP**

The frayed fabric edges add a shabby-chic charm, but if you prefer you can seal the edges of the embroidery with fabric sealer.

01 Trace the birdhouse, bird, and flower box embroidery patterns onto the light-colored cotton fabric. Working with the fabric in an embroidery hoop, embroider the designs using three strands of embroidery floss. Use stem stitch for most curved lines, backstitch for most straight lines, small French knots for the bird's eyes, larger French knots for the polka dots on the bird's headscarf and the buds in the flower box, and lazy daisy stitches for the headscarf ties and the flowers.

02 Cut out around the marked outline of the embroidered pieces. Pin the birdhouse onto brown felt, and the bird and flower box onto light blue felt. Stitch in place using three strands of embroidery floss and running stitch (for the birdhouse, you only need to stitch the sides and bottom edge). Trim the felt to match the design outline, but just a little bigger.

03 Using the template provided, cut out two roof scallops from light blue felt. Pin to the top of the house with the points meeting at the center. Stitch along the scallops using three strands of embroidery floss and running stitch.

04 Cut out a heart from red felt. Stitch it in place at the peak of the roof using three strands of embroidery floss and running stitch, working all the way around the edge of the heart.

05 Cut two narrow strips of red felt. Stitch the top of one strip to the bottom edge at the back of the birdhouse. Work a line of running stitch down the center of the strip, then stitch it to the back of the top edge of the flower box. Be sure to stitch only through the felt, not the embroidered fabric. Repeat for the other felt strip.

06 Stitch the bird to the left-hand side at the front of the birdhouse, overlapping the picket fence. Working from the back, take a few stitches through the birdhouse and through the felt layer only of the bird. Secure with a small knot.

07 Using all six strands of the embroidery floss, make a hanger. Tie a knot in one end of a 12" (30 cm) length, then stitch through the top of the roof, behind the heart. Leave a loop of thread and stitch through the felt again, tying a knot.

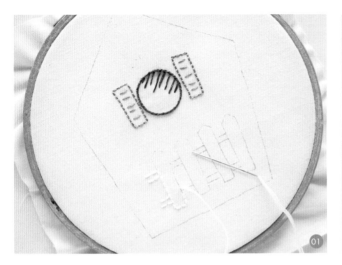

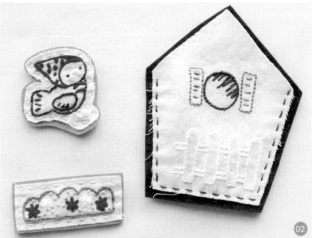

## MOLLIE JOHANSON

Mollie Johanson began her blog Wild Olive as a creative outlet. Dreaming and doodling have resulted in embroidery and paper projects, most featuring simply expressive faces. Mollie lives near Chicago, commuting daily to her in-home studio via the coffee pot. www.wildolive.blogspot.co.uk

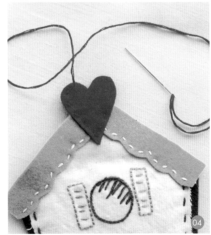

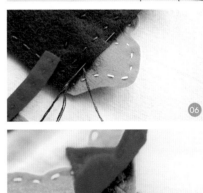

# EMBROIDERED APPLIQUÉ
# SWALLOWS CLOTHES PIN BAG

CHEER UP THE HUMDRUM TASK OF HANGING OUT THE WASHING WITH A FRESHLY EMBROIDERED BAG. REMINISCENT OF 1950s VINTAGE EMBROIDERY DESIGNS, YOU'LL LOVE CREATING THESE ELEGANT SWALLOWS IN SIMPLE STITCHES AND THE CHANCE TO APPLIQUÉ A WHOLE NEW WARDROBE OF MINIATURE CLOTHES.

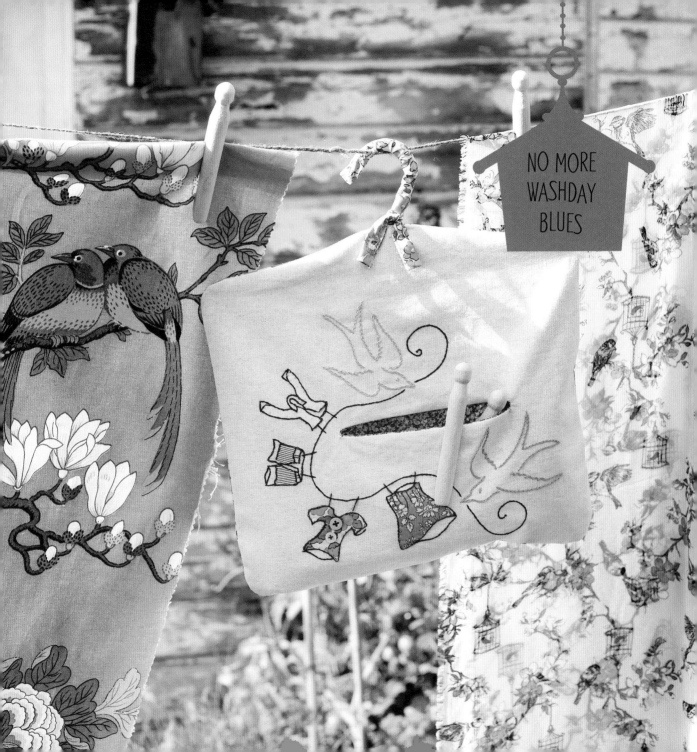

NO MORE
WASHDAY
BLUES

# HOW TO MAKE ... SWALLOWS CLOTHES PIN BAG

## MATERIALS

ONE PIECE OF EMBROIDERY LINEN MEASURING 12½" x 12" (32 x 30 CM)

TWO PIECES OF PRINTED FABRIC MEASURING 12½" x 12" (32 x 30 CM) FOR BACK AND LINING

SCRAPS OF LIGHTWEIGHT PRINTED COTTON FABRIC

EMBROIDERY FLOSS: DARK TURQUOISE, LIGHT TURQUOISE, AND DARK GRAY

TWO SMALL BUTTONS

MINI HANGER

DOUBLE-SIDED FUSIBLE WEBBING AND IRON

EMBROIDERY TRANSFER PEN

SMALL EMBROIDERY HOOP AND EMBROIDERY NEEDLE

PINS, SEWING NEEDLE, AND SCISSORS

SEWING MACHINE (OPTIONAL)

01 Trace the embroidery and appliqué design onto the linen. Start by stitching the lower bluebird, centering that part of the design in the embroidery hoop. Using two strands of embroidery floss and chain stitch, work the lower bird in dark turquoise, then reposition the fabric in the hoop to work the top bird in light turquoise. Next, stitch the washing line using one strand of gray embroidery floss and chain stitch.

02 To make the clothes, trace off the main shape of each clothing item to make templates for the skirt, blouse, shorts, and shirt. Iron double-sided fusible webbing onto the back of your print fabric scraps and use the templates to cut out each clothing shape. Iron each shape into position.

03 Using one strand of dark gray embroidery floss and dainty chain stitch, work around the clothing outlines, then work the details. Stitch lines to represent clothes pins and sew the two small buttons onto the blouse. Rub away any blue pen marks that show through your stitching.

04 Use the bag template to cut your embroidered linen into the shape of the bag. Also cut a lining and back

from your printed fabrics, and put to one side. Mark the position of the opening on the embroidered linen front. Place the embroidered linen front on top of the lining fabric with right sides together, and pin. Stitch a line around the marked opening, ¼" (6 mm) away from it. Carefully cut through both fabric layers along the line of the opening.

05 Fold the embroidered front of the bag through the opening and press to give a professional finish.

06 Place the lined front on top of the bag back, right sides together, and stitch all around the outer edge, leaving a tiny gap at the top. Turn right side out through the front opening and press.

07 Make a tiny tube of fabric by doubling over a narrow strip of the back fabric and sewing along the long edge. Thread onto the hook of your hanger and gather the lines of stitching so that it is a little ruched.

08 Post the hanger into the bag opening and push the hook out through the tiny gap left at the top. To finish, add a little tie of matching fabric to the base of the hook.

SEE PAGE 91 FOR TEMPLATE

### JENNY DIXON

A craft journalist by trade, Jenny has always loved to make things. She is based in Bath in the U.K., where she shares her home with an outrageously large fabric stash. Find her online at:
www.jennysbuttonjar.wordpress.com

01

02

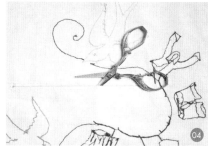

04

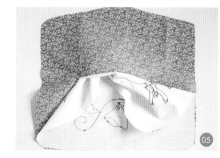

05

06

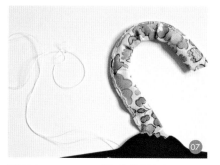

07

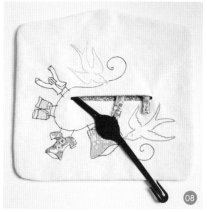

08

# FABRIC STITCHED
# PARROT ON A PERCH

THIS QUIRKY LITTLE CHARACTER IN ZINGY COLOURS WILL BRIGHTEN UP ANY ROOM AND WOULD MAKE A LOVELY GIFT FOR A NEWBORN BABY, HANGING SAFELY OUT OF REACH ABOVE THE CRIB. THE FINISHED BIRD MEASURES ABOUT 10" (25 CM) LONG — INCLUDING TAIL — BY 2" (5 CM) WIDE.

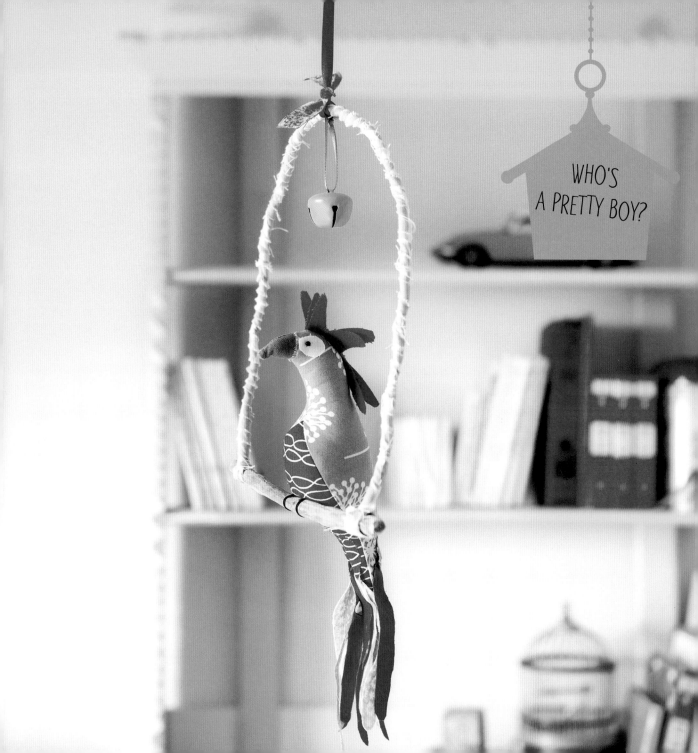

WHO'S A PRETTY BOY?

# HOW TO MAKE ... PARROT ON A PERCH

## MATERIALS

ONE PIECE OF GREEN PRINTED FABRIC
MEASURING 5½" x 8" (14 x 20 CM)

ONE PIECE OF RED PRINTED FABRIC
MEASURING 2¼" x 6" (6 x 15 CM)

STRIP OF PRINTED FABRIC MEASURING
ABOUT 1½" x 40" (4 x 100 CM)

FABRIC SCRAPS: RED, BLUE, GRAY, YELLOW,
AND WHITE

POLYESTER TOY STUFFING

DRIFTWOOD STICK OR SMALL LENGTH OF
DOWELING

TWO SMALL BLACK SEED BEADS, SEWING
NEEDLE, AND THREAD

LARGE JINGLE BELL AND LENGTH OF RED
RIBBON

CRAFT WIRE OR THIN GARDEN WIRE

GLUE STICK AND SUPERGLUE

SCISSORS AND WIRE CUTTERS

SEWING MACHINE

01 Use the templates to cut two body pieces from green printed fabric, one belly from red printed fabric, two beaks from gray fabric, three head feathers from red fabric, two eye patches from white fabric and ten tail feathers from fabric scraps.

02 Take one body piece and lay one beak shape over the matching area of the head, both right sides up. Use a small zigzag stitch to machine sew together. Repeat for the remaining body and beak. Trim away the green fabric beneath the beak.

03 Lay one body piece right side up and place the three head feathers, with feathers pointing downward, to align at points A and B on the parrot's head. Place the second body piece on top, right side down. Use straight machine stitch to sew from A to C ,allowing for an ⅛" (3 mm) seam allowance.

04 Open out the parrot's body slightly and place the belly along one side, right sides facing. Machine stitch together from X to Y. Repeat along the opposite side. Finish stitching around the beak and head. Turn inside out through the tail and stuff

tightly with the polyester stuffing, before sewing up the tail.

05 Using a glue stick, stick on the eye patches and then sew on the seed bead eyes. Stick on the tail feathers, laying each one slightly over the next, five on top of the tail and five beneath. To tidy up this area, you can add a couple of feathers cut from the body and belly fabrics at the joins.

06 To make the parrot's perch, wrap one end of the wire around the end of the stick, bend into a U shape and wrap the other end as before. Trim away any excess wire. Cover the wire using strips of fabric, binding tightly so it is completely covered.

07 Holding the perch in place under the parrot's belly, sew through the fabric and around the stick to create the parrot's claws as you attach him to his perch. A spot of superglue where the belly meets the perch will secure the parrot in place.

08 Thread the jingle bell onto a short piece of ribbon and tie centrally above the parrot. Add a longer length of ribbon to suspend the bird's perch from the ceiling.

SEE PAGE 93 FOR TEMPLATES

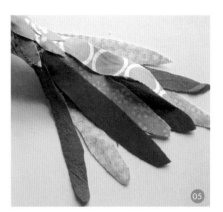
02

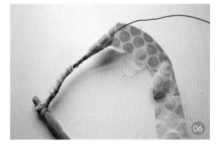
05

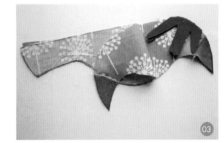
03

### KIRSTY ELSON

Kirsty is a multi-media artist living in Cornwall, U.K. specializing in driftwood sculpture and paper collage. A self-confessed fabric addict, she loves to play around on the sewing machine.
To find out more visit
www.kirstyelsondesigns.co.uk

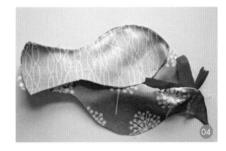
04

### TIP
You can make your parrot as flamboyant as you like. Try adding brightly colored feathers to his head, or fashion him some wings.

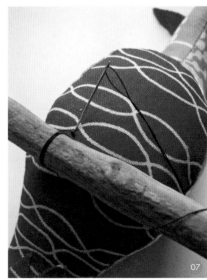
07

06

## FELT APPLIQUÉ
# COCKEREL COZY

THIS BRIGHT, COLORFUL FRENCH PRESS COZY, WITH ITS TRIO OF MATCHING COASTERS, WAS INSPIRED BY *WYCINANKI* (PRONOUNCED VEE-CHEE-NON-KEY), THE TRADITIONAL POLISH CRAFT OF PAPER CUTTING. DON'T DRINK COFFEE? NO WORRIES — YOU COULD ENLARGE THE COCKEREL MOTIF AND USE IT TO DECORATE A TEAPOT COZY.

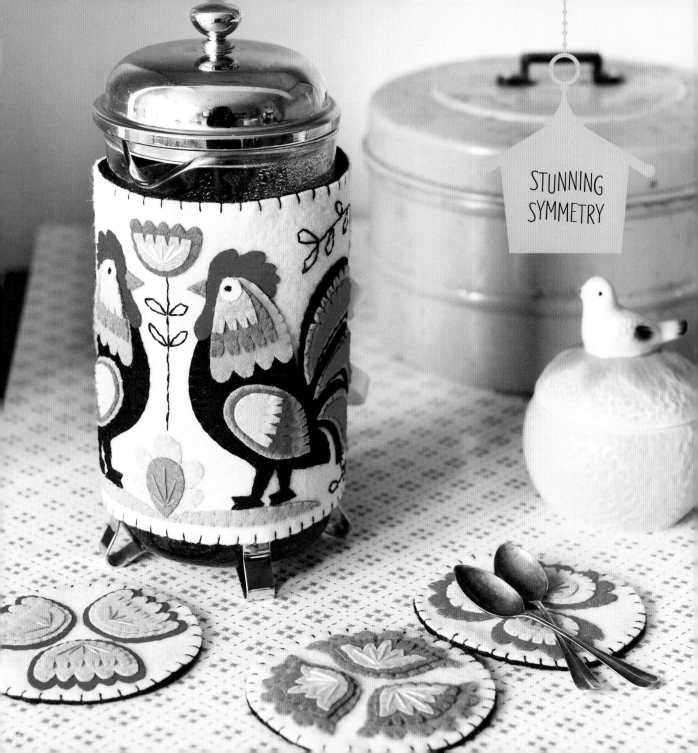

STUNNING
SYMMETRY

# HOW TO MAKE ... COCKEREL COZY

## MATERIALS

TWO SHEETS OF WHITE FELT MEASURING
9" x 12" (23 x 30.5 cm)

THREE SHEETS OF BLACK FELT MEASURING
9" x 12" (23 x 30.5 cm)

ONE PIECE OF BLUE FELT MEASURING
4" x 7" (10 x 18 cm)

ONE PIECE EACH OF ORANGE AND SPRING
GREEN FELT MEASURING 4" x 6" (10 x 15 cm)

ONE PIECE EACH OF RED, LIGHT BLUE,
YELLOW, TURQUOISE, PINK, AND BRIGHT PINK
FELT MEASURING 4" x 5" (10 x 12.5 cm)

ONE PIECE OF DARK ORANGE FELT
MEASURING 2" x 3½" (5 x 9 cm)

SEWING THREADS TO MATCH FELT COLORS

EMBROIDERY FLOSS IN BLACK AND
ASSORTED BRIGHT COLORS

44" (112 cm) OF ⅜" (1 cm) WIDE WHITE
RIBBON

NEEDLES: SEWING AND EMBROIDERY

PINS AND SCISSORS

## HOW TO MAKE ... THE COZY

01 Cut a white felt rectangle measuring 5¾" x 11¾" (14.5 x 30 cm). This is your base on which your colorful appliqué design will be built up layer by layer.

02 Use the templates provided to cut out all the cockerel cozy pieces required for the appliqué design in the quantities and colors marked on the template page. As the design is symmetrical, most of the templates will be used to cut two pieces. The templates given are for the left-hand side of the cozy; you will need to flip the templates over before cutting the second piece (for the right-hand side). As the design is built up in layers (A, B, C, and D), it will help if you keep all the motifs for each layer together as you cut them out.

03 Some of the templates are marked with lines of Vs. Use these as a guide to show you where to make small, V-shaped cuts along the edge of your felt shapes with your scissors.

04 Lay the white felt rectangle on your work surface and arrange the bottom layer of appliqué (all the A motifs) as pictured. Pin and then baste in place

with large white stitches (secured very loosely at the back for easy removal). Remove the pins and sew all the shapes in place using whip stitch in matching sewing threads. When all the shapes have been stitched, remove the basting stitches.

05 Now lay down the second layer of appliqué (all the B motifs) and sew in place, again using whip stitch and matching sewing thread.

06 Continue on to the third layer of appliqué (all the C motifs). As the layers get thicker, you may find it easier to hold the shapes in position as you sew instead of pinning them.

07 Finally, place the fourth layer of appliqué (all the D motifs). Now sew the eyes in place with white whip stitches. Use three strands of embroidery floss to stitch the pupil of each eye, sewing small stitches over and over to create the pupil shape.

DESIGNED
BY LAURA
HOWARD

SEE PAGE 94 FOR TEMPLATES

SEE PAGE 94 FOR TEMPLATES

**TIP**

When cutting out small or fiddly shapes, you may find it easier to hold the templates onto the felt or to use sticky tape instead of pinning them.

**TIP**

If you prefer, you can use a black seed bead for each pupil and sew it in place securely with black sewing thread.

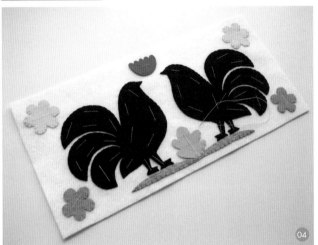

04

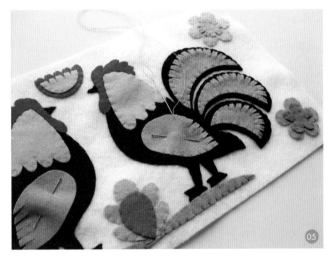

05

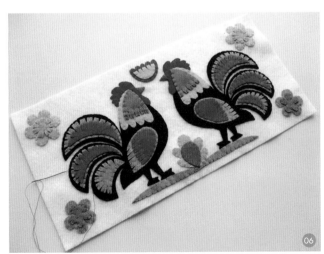

06

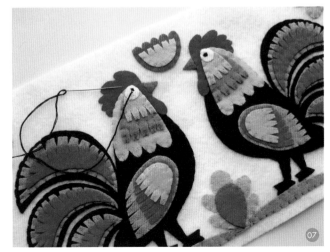

07

08 Add the embroidered details to the flowers on the cozy using three strands of embroidery floss in bright, contrasting colors to sew long single stitches in a fan or starburst shape as pictured.

09 Use three strands of black embroidery floss and backstitch to add the embroidered vines and leaves to the design. Stitch a line for each vine and then add leaves worked with lazy daisy stitch. Take care not to pull your stitches too tight or you will pucker the felt.

10 Cut a black felt rectangle measuring 5¾" x 11¾" (14.5 x 30 cm). This is for the backing. Pin the black backing piece to the undecorated side of the white front piece. Trim off any excess felt from the black piece (all the stitching on the white piece may have caused it to shrink slightly). Remove the pins and set the white front piece aside.

11 Cut four lengths of white ribbon, each measuring 11" (28 cm), and trim the ends at an angle. Pin two of the ribbon lengths to one short end of the backing piece, overlapping it by an inch. Sew in place with whip

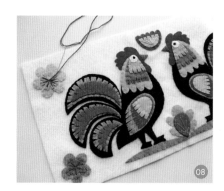

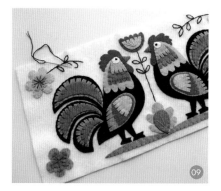

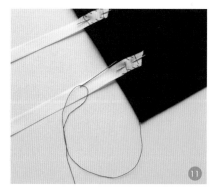

stitches using black sewing thread and sewing into the felt instead of all the way through it. Sew the other two ribbon lengths to the other short end, lining them up perfectly with the first two ribbons so they'll match up when tied. (The exact positioning of the ribbons on the felt will vary depending on the position of the handle on your cafetiere.)

12 Pin the front (white) and back (black) cozy pieces together and use three strands of black embroidery floss to sew around the edge with neat blanket stitch. When sewing across the ribbons, sew a single whip stitch and resume the blanket stitch immediately afterward. Finish your stitching neatly at the back.

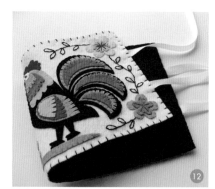

TIP

The flowers from the coasters would make pretty hairclips or brooches and a perfect last-minute gift.

# HOW TO MAKE ... THE COASTERS

01 Cut three 4" (10 cm) diameter circles from white felt for the base upon which you will build up the appliqué designs in layers. Use the templates provided to cut out all the appliqué pieces, and use the Vs marked on them as a guide for making small V-shaped cuts along some of the edges.

02 For each coaster, arrange the largest shapes (motifs A) on a white circle. Pin and then sew in place with whip stitch in matching sewing thread.

03 Sew the next two layers (motifs B, then motifs C) with more whip stitches in matching thread. Then use three strands of embroidery floss in a bright contrasting color to sew a fan shape of straight stitches as pictured.

04 Cut three 4" (10 cm) diameter circles from black felt for the coasters' backings. Pin the front (white) and back (black) circles together and stitch around the edge with blanket stitch using three strands of black embroidery floss. Finish neatly at the back.

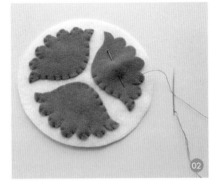

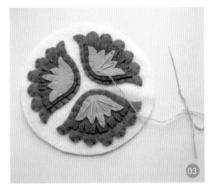

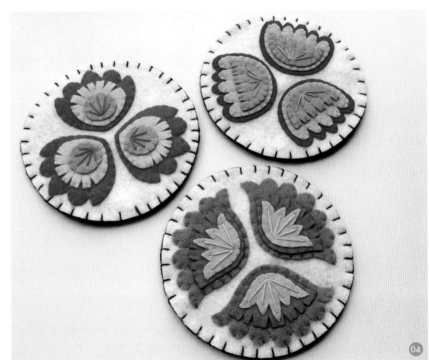

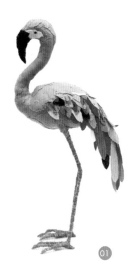

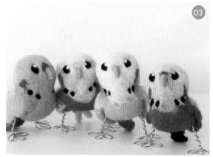

# CRACKING IDEAS

FEATHERED FRIENDS

## 01

London-based textile artist and illustrator Abigail Brown describes herself as an extreme hoarder and tremendous mess maker. She uses her ever-growing stash of new and reused fabrics to craft incredibly lifelike creatures, such as this beautiful flamingo from her bird species collection. Her work is all hand sewn with great love and attention to detail. www.abigail-brown.co.uk

## 02

Anya Keeley's Hereford workshop in the U.K. is stacked to the roof with suitcases of ephemera, jars of buttons and drawers full of bits and bobs inspiring her to create her collection of curious curiosities and whimsical wonders. Each design is a one-off, just like Henry the Puffin, fashioned from wire and papier mâché. For more of her creations see www.anyakeeley.com

## 03

Melanie Ann Green (aka Feltmeupdesigns) aims to capture the distinct personalities of domestic and wild birds in her needle felt sculptures. Her bird portraits are full of life, from sweet little budgies with their quizzical expressions, heads slightly cocked, to brazen toucans and their cheeky antics. Find out more about her latest designs at feltmeupdesigns.blogspot.co.uk

OWL LOVE

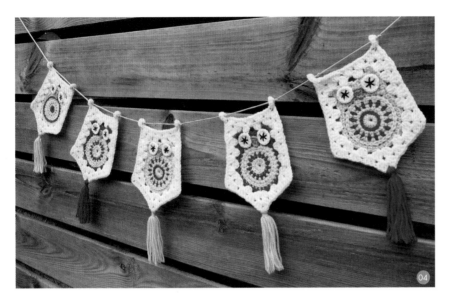

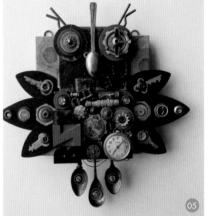

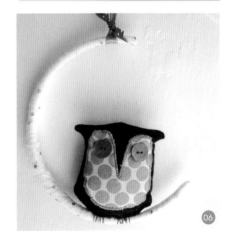

## 04

Greta Tulner turned her passion for crochet into her day job selling her wonderfully colorful and inventive patterns on Etsy. Her owl garland takes the granny square into a whole new realm and you can find more of her designs at www.Atergcrochet.etsy.com

## 05

Seattle-based artist Jen Hardwick creates collages using new and recycled materials. To make her wise old birds she uses keys, acrylic paint, metal doors, book pages, spoons, salvaged metal, watch and radio parts, buttons, letter press blocks, glass vial, and wood pieces. For more of her unusual designs see www.redhardwick.etsy.com

## 06

This sweet little owl in the moon mobile is another great fabric creation from Kirsty Elson, the designer of Parrot on a Perch (p56). The little bird has a lime and white polka dot tummy and lovely blue button eyes, and is stuffed with lavender to aid sleep when hung in the bedroom. For more of Kirsty's work visit www.kirstyelsondesigns.co.uk

## WIRE AND BEAD

# BIRDCAGE DREAM CATCHER

THE NATIVE AMERICANS BELIEVED THAT A DREAM CATCHER COULD PROTECT THE SLEEPER THROUGH THE NIGHT, CAPTURING BAD DREAMS AT ITS WOVEN CENTER. THIS VINTAGE-STYLE BIRDCAGE-SHAPED DREAM CATCHER, MADE OF WIRE, FABRIC, BEADS, AND FEATHERS, IS A DECORATIVE WAY TO ENSURE ALL YOUR DREAMS ARE SWEET ONES.

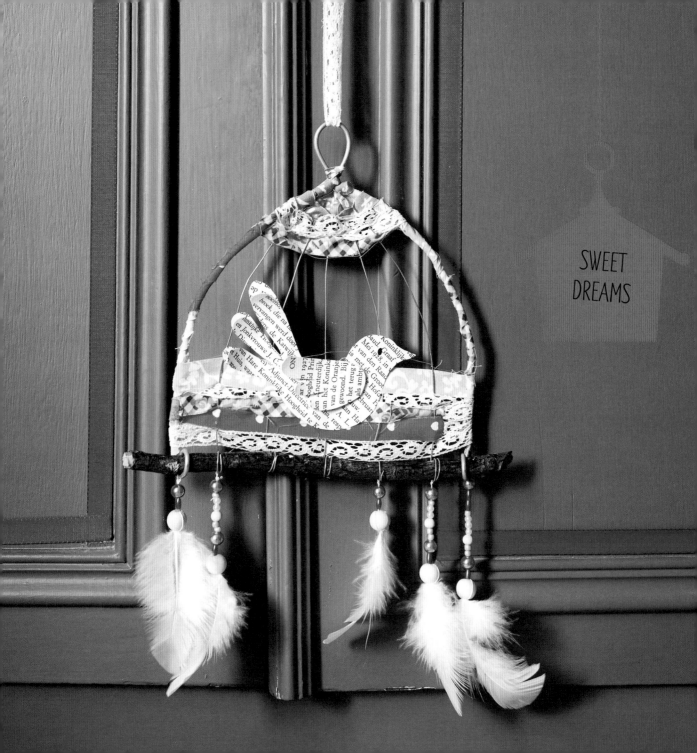

SWEET
DREAMS

# HOW TO MAKE ... BIRDCAGE DREAM CATCHER

## MATERIALS

IRON WIRE IN THREE DIFFERENT THICKNESSES: THICK, MEDIUM, AND VERY THIN

TWIG ABOUT 8½" (22 CM) LONG

STRIPS OF PATTERNED FABRIC AND LACE RIBBON

BEADS OF VARIOUS SHAPES, COLORS AND SIZES, INCLUDING A FEW LARGE WOODEN BEADS

SOME FEATHERS

PAGES FROM AN OLD BOOK

DOUBLE-SIDED ADHESIVE TAPE

GLUE GUN

STRONG THREAD

WIRE CUTTERS AND PLIERS

### TIP

For a more contemporary look, use brightly colored patterned paper for the bird, ribbon instead of lace, and choose colored feathers and sparkling beads.

01 Trace off the birdcage template and use as a guide to cut and bend the thickest wire into the outline shape of the birdcage (marked A on the template). Bend the ends of the wire around either end of the twig.

02 Cut five pieces of medium wire (for the vertical bars) and attach to the hanging loop at the top of the birdcage. Shape the bars and twist the end of each a couple of times around the twig (marked B on the template).

03 Use some very thin wire to make the two horizontal bars (marked C on the template), and twist around every vertical bar to fasten.

04 Cut narrow strips of patterned fabric about ⅝" (1.5 cm) wide. Cover the thick wire with double-sided adhesive tape. Remove the tape backing and twist the fabric strips around, leaving the hanging loop uncovered at the top.

05 Cut more narrow strips of patterned fabric and sew these to strips of lace ribbon to make a long fabric/lace strip. Weave the fabric/lace strip through the bars in the bottom third and top third of the birdcage. Attach

the ends with double-sided tape or stitch by hand.

06 Using the bird and wing templates, make the bird out of paper recycled from an old book. Cut one bird, two wings, and one tail. Glue the tail under the bird, leaving the tail feathers loose. Glue one wing on top of the other, but leave the end of the feathers unstuck. Gently curl the unglued upper feathers of the tail and wing.

07 Fasten the end of a piece of strong thread through and around a wooden bead, then string on more beads. Use the glue gun to put a little glue into the bottom hole of the wooden bead and insert a feather; leave to dry. Make five decorated strings in all, of varying lengths.

08 Tie the decorated strings onto the wire loops at the base of the birdcage. Knot tightly and pull the end of the thread back through the beads before trimming.

09 Finally, use the glue gun to attach the paper bird onto the decorated birdcage. Tie a long piece of lace ribbon through the hanging loop and it is ready to hang.

SEE PAGE
92 FOR
TEMPLATES

### ELINE PELLINKHOF

Eline lives in the Netherlands where
she works as a freelance designer
and author of craft books. She loves
to combine unexpected materials
and techniques in her projects and is
very much inspired by embroidery,
vintage postcards, flowers, and
brightly colored fabrics from far off
lands. Find her online at
elinepellinkhof.blogspot.com

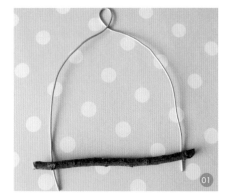

01

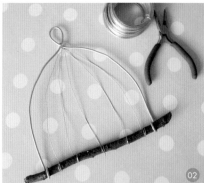

02

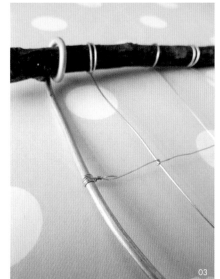

03

05

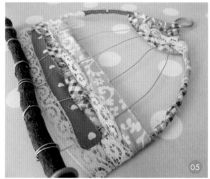

06

04

08

## STAMPED AND SEWN
# PARTY BIRD BRUSH ROLL

KEEP YOUR MAKE-UP BRUSHES SAFE AND SOUND IN THIS PRETTY FABRIC ROLL. LINED
WITH BIRD-PRINTED MATERIAL, THE FRONT IS DECORATED WITH A SWEET LITTLE BIRD,
WEARING HER PRETTY PARTY CROWN, AND A GORGEOUS FABRIC RUFFLE.
A SUMPTUOUS VELVET RIBBON KEEPS THE ROLL IN PLACE.

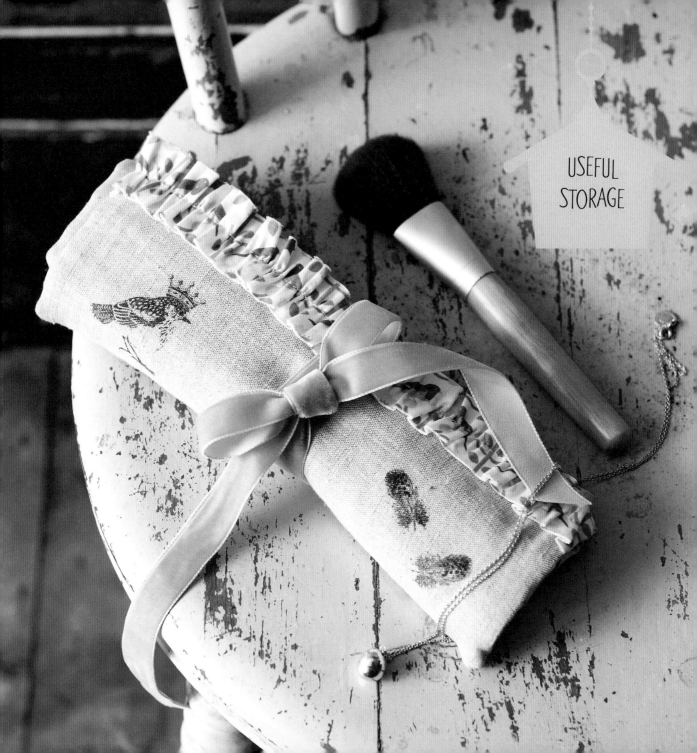

# HOW TO MAKE ... PARTY BIRD BRUSH ROLL

## MATERIALS

NATURAL LINEN: ONE PIECE MEASURING 10" x 12½" (25 x 32 CM) AND ONE PIECE MEASURING 9" x 13½" (23 x 34 CM)

BIRD-PRINTED FABRIC: ONE PIECE MEASURING 10" x 12½" (25 x 32 CM) AND ONE STRIP MEASURING 19⅝" x 1⅛" (50 x 3 CM)

ONE PIECE OF COTTON BATTING MEASURING 10" x 12½" (25 x 32 CM)

VELVET RIBBON, 53" (135 CM) AND COTTON LACE TRIM, 14" (35 CM)

MEDIUM-WEIGHT FUSIBLE INTERFACING

BIRD-THEMED RUBBER STAMPS (USED HERE: BIRD NOTES CLEAR ART STAMPS BY CRAFTY SECRETS)

BLACK INK PAD (USED HERE: VERSACRAFT) AND ACRYLIC STAMP BLOCK

CUTTING MAT, ROTARY CUTTER, AND SCISSORS

RULER AND PENCIL

SEWING MACHINE AND IRON

01 Cut a strip of fusible interfacing 20" x 1⅛" (50 x 3 cm) and iron onto the wrong side of the bird-printed fabric strip. Using the longest straight stitch on your machine and a matching thread, stitch down the center. Pull one end of the thread to gather the fabric to just over 10" (25 cm). Fasten the ends, even the ruffles and press gently. Set aside.

02 Take the 9" x 13½" (23 x 34 cm) piece of linen (for the pocket), fold in half lengthways, and press. Pin and stitch the lace, then a strip of velvet ribbon, along the folded edge.

03 Cut a piece of fusible interfacing 10" x 12½" (25 x 32 cm) and iron onto the wrong side of the same-sized piece of bird-printed fabric. Place the decorated linen pocket along the bottom edge of the printed fabric (right sides facing up), aligning the raw edges and allowing a little overlap at each side. Insert a couple of pins to hold together, then turn over (wrong side up) and pin along the bottom and sides.

04 Continuing to work on the wrong side, draw on the stitching lines for the pockets (six lines will give seven pockets). Starting with the central line, and using natural-colored thread, start stitching from the bottom edge until you can feel the top of the pocket; then follow the stitching line back down again.

05 Now stitch down each side of the pocket strip just a little way from the edges. Trim the excess fabric.

## JOOLES OF SEW SWEET VIOLET

Jooles, a lover of sewing, other craftiness and eating cake, lives in West Sussex, U.K. with her husband and her two gorgeous teenagers. A homebody, she loves nothing more than a whole day spent tinkering away in her sewing room. Visit her blog at sewsweetviolet.blogspot.com or discover more of her work at sewsweetviolet.etsy.com

**06** Take the second piece of linen and mark a line (using pins) 2¾" (7 cm) up from one short end. Pin on the ruffle and stitch along its center. Ink the bird and stamp firmly onto the fabric below the ruffle. Stamp the bird's crown by making a mask from a sticky note. Stamp the feathers. Heat set the stamped images on the wrong side of the fabric.

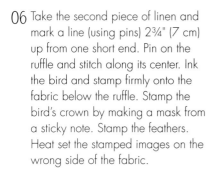

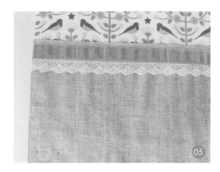

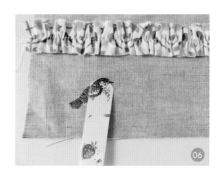

**07** To assemble the brush roll, lay the cotton batting on a flat surface and place the pocket layer right side up on top. Fold the remaining velvet ribbon in half right sides together and place just above the pocket to the left. Lay the front layer on top, right side down, stamped edge to the left. Pin.

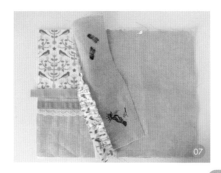

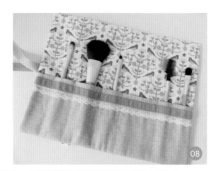

**08** Stitch ⅜" (1 cm) from the edge, leaving a turning gap. Trim the corners, turn the right way out and press. Blindstitch the opening closed by hand and fill the pockets with brushes. Roll up and tie a bow.

## TIP
Pocket sizes can be adapted to fit your brushes. Practice your stamping technique first on some scrap fabric until you are completely happy.

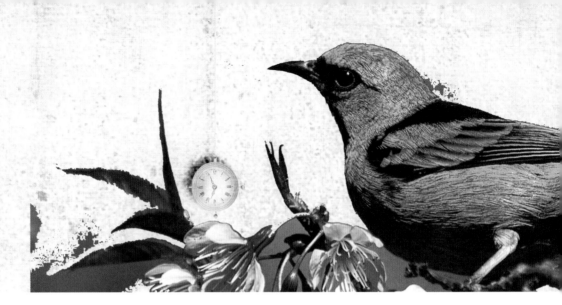

# FUN TO CROCHET
# NESTING CHICKS

DON'T WAIT FOR EASTER TO BRING THESE THREE LITTLE CHICKS OUT — LET THEM BRING SOME CROCHET CUTENESS TO A COZY CORNER OF YOUR HOUSE ALL YEAR LONG. THESE LITTLE STUFFED FIGURES ARE SIMPLE TO MAKE IN ROUNDS OF SINGLE CROCHET, WHILE EMBROIDERED FEATURES ADD EXTRA CHARACTER.

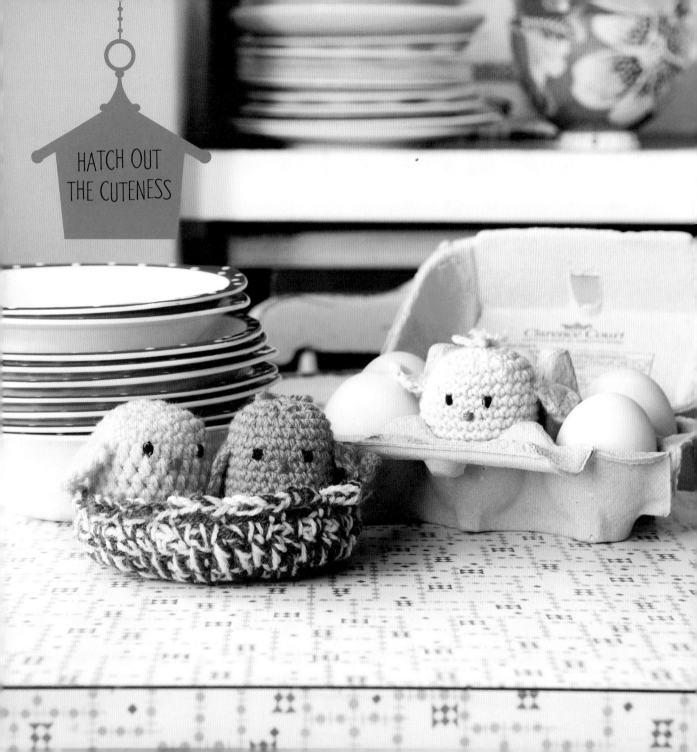

HATCH OUT
THE CUTENESS

# HOW TO MAKE ... NESTING CHICKS

## MATERIALS

50ɢ BALLS (145 YARDS/133 METERS) OF ANNELL RAPIDO, ONE EACH IN PINK #3277 (A), YELLOW #3215 (B), LIGHT CYAN #3222 (C), BROWN #3211 (D), AND SAND #3361 (E), OR SIMILAR YARN (DK-WEIGHT ACRYLIC)

CROCHET HOOKS, SIZE C2/D3 (3 ᴍᴍ) AND SIZE 7 (4.5 ᴍᴍ)

TAPESTRY NEEDLE

SEWING NEEDLE

SEWING THREAD: ORANGE AND BLACK

POLYESTER TOY STUFFING

## GAUGE TIP

Gauge is not important for this project, as long as you make the crochet fabric nice and dense so the chicks can be stuffed firmly and retain their rounded shapes.

01 Make the chicks.

You can either start from the head or start at the base – the end result will look the same. For the pink and blue chicks, the yarn ends were left poking out at the top of the heads to look like tufts of feathers. Weave the ends in if you prefer.

Using C2/D3 crochet hook, make one chick in each of yarns A, B, and C.

Ch4 and join with sl st to form the foundation ring.

**Round 1:** Ch2, then work 7sc into the ring. Sl st in 2nd ch of initial ch2 to join the round. (8sc)

**Round 2:** Ch2, 1sc in the same point, *2sc in next st, rep from * to end. Sl st to join the round. (16sc)

**Round 3:** Ch2, 1sc in the same point, *1sc in next st, 2sc in next st, rep from * to end. Sl st to join the round. (24sc)

**Round 4:** Ch2, 1sc in the same point, *2sc in next st, rep from * to end. Sl st to join the round. (48sc)

**Rounds 5–9:** Ch2, *1sc in next st, rep from * to end. Sl st to join the round. (48sc)

Insert the polyester stuffing.

**Round 10:** Ch2, 1sc in next st, *skip 1 st, 1sc in next 2 sts, rep from * to end. Sl st to join the round. (32sc)

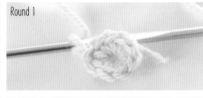

Round 1

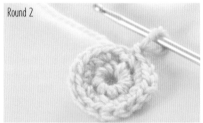

Round 2

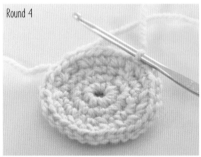

Round 4

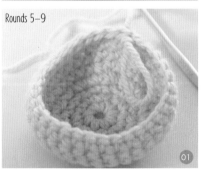

Rounds 5–9

01

**Round 11:** Ch2, *1sc in next st, rep from * to end. Sl st to join the round. (32sc)

**Round 12:** Ch2, *skip 1 st, 1sc in next st, rep from * to end. Sl st to join the round. (16sc)

Insert more stuffing to round out the chick if necessary.

**Round 13:** Ch2, *skip 1 st, 1sc in next st, rep from * to end. Sl st to join the round. (8sc)

Using a tapestry needle, draw the yarn through the remaining sts and pull up tight to close the gap. Fasten off and weave in ends.

02 Make the wings.

Using C2/D3 crochet hook, make two wings for each chick using yarn A, B or C as appropriate.

Ch7 to make the foundation row.

**Row 1:** 1hdc in 3rd ch from hook, 1hdc in each ch across, turn. (5hdc)

**Row 2:** Ch2 (counts as 1hdc), 1hdc in each hdc, turn.

**Row 3:** Sl st in first hdc, ch2 (counts as 1hdc), 1hdc in each hdc. (4hdc)

**Row 4:** Ch2 (counts as 1hdc), 1hdc in each hdc.

Fasten off and weave in ends.

03 Sew on the wings.

Count down five rounds from the top of the chick's body as a guide and sew on the first wing. Sew the other wing to the opposite side of the body.

04 Embroider the chicks' features.

Using the photograph as a guide, embroider the chicks' features, using black sewing thread for the eyes and orange for the beak.

05 Make the nest.

Using size 7 crochet hook and holding yarns D and E together, ch4 and join with sl st to form the foundation ring.

**Round 1:** Ch2, then work 7dc into the ring. Sl st in 2nd ch of initial ch2 to join the round. (8tr)

**Round 2:** Ch2, 1dc in the same point, *2dc in next st, rep from * to end. Sl st to join the round. (16dc)

**Round 3:** Ch2, 1dc in the same point, *1dc in next st, 2dc in next st, rep from * to end. Sl st to join the round. (24dc)

**Round 4:** Ch2, 1dc in the same point, *2dc in next st, rep from * to end. Sl st to join the round. (48dc)

**Round 5:** Ch2, 1dc in the same point, *1dc in next st, 2dc in next st, rep from * to end. Sl st to join the round. (72dc)

**Rounds 6–7:** Ch2, *1dc in next dc, rep from* to end. (72dc)

**Round 8:** *Ch5, skip 4dc, 1sc into the top of the dc in the round below, rep from * to end. Sl st to join the round.

Fasten off and weave in ends.

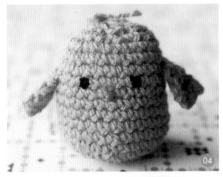

## Abbreviations

**(US terms used throughout)**

**ch:** chain

**dc:** double crochet

**hdc:** half double crochet

**rep:** repeat

**sc:** single crochet

**sl st:** slip(ped) stitch

US/UK differences:

US sc (single crochet) = UK dc (double crochet)

US hdc (half double crochet) = UK htr (half treble crochet)

US dc (double crochet) = UK tr (treble crochet)

DESIGNED BY ILARIA CHIARATTI

## LINO-CUT
# WOODPECKER NOTEBOOK

THIS LITTLE COVERED NOTEBOOK, PRINTED WITH A HAND-CUT WOODPECKER DESIGN, IS SMALL ENOUGH TO FIT IN YOUR POCKET — IDEAL FOR RECORDING YOUR CREATIVE INSPIRATIONS. THE NOTEBOOK IS 4" x 5½" (10 x 14 CM) AND THE DESIGN CAN BE ADJUSTED TO FIT LARGER ONES BY MAKING THE TREE TRUNK LONGER.

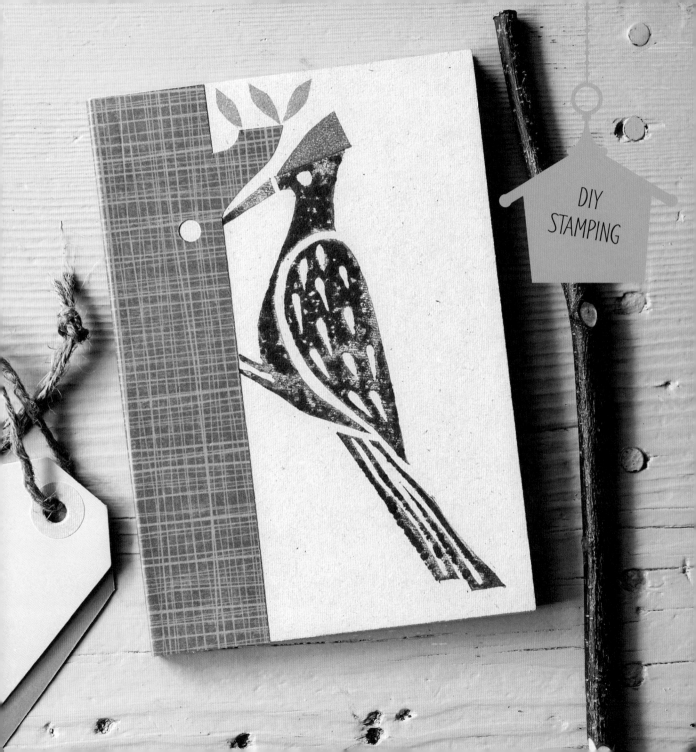

DIY
STAMPING

# HOW TO MAKE ... WOODPECKER NOTEBOOK

## MATERIALS

SMALL NOTEBOOK 4" x 5½" (10 x 14 CM)

TWO PIECES OF NATURAL-COLORED THIN CARD MEASURING 4" x 5½" (10 x 14 CM)

ONE PIECE OF BROWN PRINTED PAPER MEASURING 4" x 6" (10 x 15 CM)

INK PADS: BLACK, RED, AND ORANGE

SPEEDY CARVE LINO BLOCK

LINO-CUTTING TOOL WITH THIN BLADE

TRACING PAPER, PENCIL, AND RULER

GLUE

HOLE PUNCH

CRAFT KNIFE AND CUTTING MAT

### TIP
Store your cut design and use it again and again to print wrapping paper and greeting cards, or to cover folders and storage boxes.

01 Trace off the woodpecker (without the crest section) from the template. Turn the tracing over and place it down onto the speedy carve lino block. Go over the lines of your tracing to transfer the design onto the block. Use the lino-cutting tool to cut out the design, first cutting carefully around the outside and then working on the details.

02 Use a craft knife to trim away the block leaving about ⅜" (1 cm) around the woodpecker outline. Now use your lino-cutting tool to cut away the rubber block up to the outline. (You may need to change to a wider blade.)

03 Make a test print: press the cut block into the black ink pad and onto a scrap piece of paper. This will show up any areas that need a bit more cutting and tidying up.

04 Take one of the pieces of thin card and draw a pencil line 1 ⅛" (3 cm) away from the left-hand edge. Print the woodpecker so that the tail is about ¼" (6 mm) up from the bottom edge and the legs are lined up to the pencil line.

SEE PAGE 92 FOR TEMPLATES

05 Trace off the crest and transfer it onto a scrap of speedy carve lino block. Cut around the pencil marks with a craft knife and use the whole piece to print the crest in red.

06 Trace off the tree and transfer it to the back of the patterned piece of paper. Cut out, turn the tree over and use a hole punch to make the woodpecker's hole.

07 Stick the stamped card to the front of the notebook and the unstamped card to the back. Glue the tree and stick around the spine (line the edge up to the pencil line on the front).

08 Cut a leaf shape out of the speedy carve lino block and use to print some leaves in orange.

DESIGNED
BY CLARE
YOUNGS

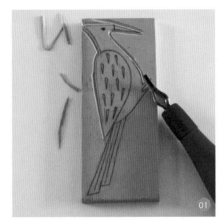

01

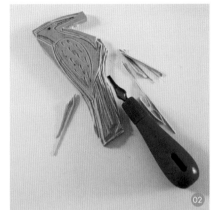

02

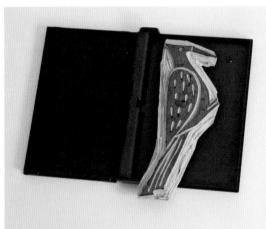

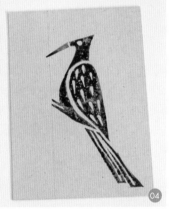

04

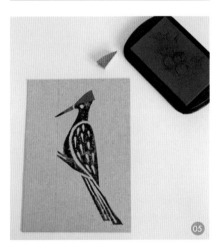

05

06

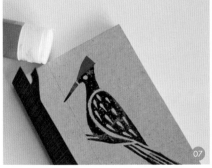

07

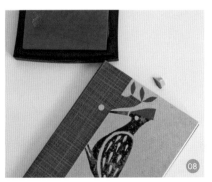

08

## GRANNY SQUARE
# LITTLE BIRD BABY BLANKET

THIS CUTE BABY BLANKET TAKES THE TRADITIONAL CROCHET GRANNY SQUARE AND GIVES IT A PLAYFUL REWORKING AS COLORFUL LITTLE BIRD MOTIFS NEST AROUND THE EDGES. THIS IS AN INSPIRING PROJECT FOR A BEGINNER LOOKING TO PROGRESS BEYOND THE SIMPLE GRANNY SQUARE. THE FINISHED BLANKET IS 35" (88 CM) SQUARE.

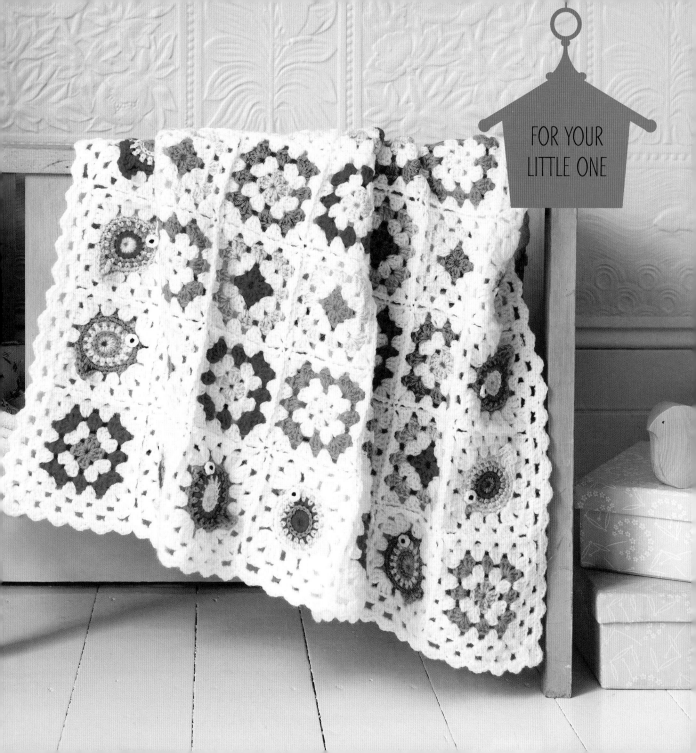

FOR YOUR
LITTLE ONE

# HOW TO MAKE ... LITTLE BIRD BABY BLANKET

## MATERIALS

50G BALLS (146 YARDS/134 METERS) OF
PHILDAR IMPACT 3.5, SIX IN BLANC #0002
(WHITE) (A) AND ONE EACH IN AUBÉPINE
#0046 (PALE PINK) (B), GRENADINE #0047
(SALMON PINK) (C), TURQUOISE #0058 (D),
OPALINE #0057 (AQUA) (E), JONQUILLE
#0049 (PALE YELLOW) (F), MENTHE #0059
(EMERALD GREEN) (G), AND TOURNESOL
#0050 (BRIGHT YELLOW) (H), OR SIMILAR
YARN (DK-WEIGHT ACRYLIC)

SMALL AMOUNT OF BLACK YARN FOR THE EYES

CROCHET HOOKS, SIZE C2 (2.75 MM) AND SIZE
G6 (4 MM)

TAPESTRY NEEDLE

### TIP

To make a picot (see Round 4 of
Step 02), ch3, then close the picot
loop with sl st in the first ch.

01 Before you start.
You can use your own colorways
for the birds and squares, but if you
want to make the blanket as it is
shown here, use these colorways.
Make 64 squares in total:
6 granny squares in each of 6
colorways shown (36 in all)
4 bird motif squares in each of 6
colorways shown (24 in all)
4 granny squares for the corners;
either repeat one of the colorways or
choose your own (4 in all).

02 Make the bird motifs (make 24;
4 each in 6 colorways).
Using G6 crochet hook, ch6 and
join with sl st to form foundation ring.
**Round 1:** Ch3 (counts as 1dc), 5dc,
4tr, 6dc, join round with sl st, break
yarn. (16 sts)
Take a small piece of yarn in a
contrast color to use as a stitch
marker and attach it to the first tr
on round 1.
**Round 2:** Attach a new color
between the 4th tr and the next dc

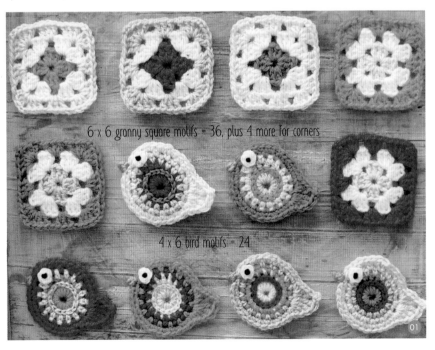

6 x 6 granny square motifs = 36, plus 4 more for corners

4 x 6 bird motifs = 24

01

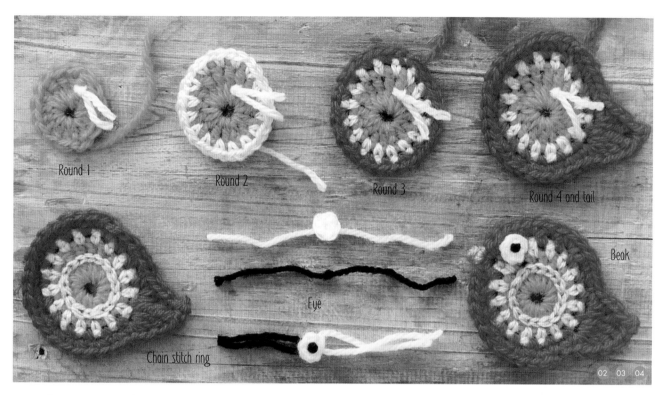

Round 1

Round 2

Round 3

Round 4 and tail

Eye

Beak

Chain stitch ring

02  03  04

on the previous round (counts as 1sc), ch1, *1sc between next 2 sts, ch1, rep from * to end, join round with sl st, break yarn. (16sc)

**Round 3:** Attach a new color in ch-sp above the first marked tr (counts as 1sc), ch1, *1sc in next ch-sp, ch1, rep from * to end, join round with sl st. (16sc)

**Round 4:** Ch1 (counts as 1sc), (2sc in next ch-sp) ten times. Make the tail as follows: (sc, hdc, dc, tr, dtr, picot) in next ch-sp, (tr, dc, hdc, sc) in next ch-sp, (2sc in next ch-sp) three times, 1sc in next ch-sp, join round with sl st, break yarn.

Using a fourth color, crochet a ring of ch sts around the middle of the first row.

03 Make the eyes for the bird motifs. Using C2 crochet hook and yarn A, ch3, 5sc in first ch, join with sl st and break yarn.
To make the pupils, cut a 4" (10 cm) length of black yarn and make a double knot in the middle.
Pull the pupil (black thread) through the center of the eye (white ring), then sew the eye to the bird motif.

04 Make the beaks for the bird motifs. Using C2 crochet hook and yarn H, attach yarn to 8th st counted from the ^ sign (see photo of bird motif above); work 2sc in the same st, break yarn. Insert hook in front of the first attached st, yarn over hook, break yarn and pull through front. Pull on both threads to form beak. Fasten off and weave in ends.

05 Make the granny squares (make 40; 6 each in 6 colorways + 4 for the corners).
Using G6 crochet hook, and the first yarn color of your choice, ch5 and

# HOW TO MAKE ... LITTLE BIRD BABY BLANKET

join with sl st to form the foundation ring.

**Round 1:** Ch3 (counts as 1dc), 2dc, ch2, (3dc, ch2) three times, join round with sl st, break yarn. (12 sts)

**Round 2:** Using yarn A, ch3 (counts as 1dc), 2dc in first ch-sp, ch2, 3dc in same ch-sp, *ch1, (3dc, ch2, 3dc) in next ch-sp, rep from * twice, ch1, join round with sl st, break yarn A. (24 sts)

**Round 3:** Using a new color yarn, ch3 (counts as 1dc), 2dc in first ch-sp, ch2, 3dc in same ch-sp, *ch1, 3dc in next ch-sp, ch1, (3dc, ch2, 3dc) in next ch-sp, rep from * twice, ch1, 3dc in next ch-sp, ch1, join round with sl st, break yarn. (36 sts) For round 4, see step 06; you will make this round when you crochet the squares together.

06 Make up the blanket.
Arrange 36 squares in order of your choice in a 6 x 6 square and join them together using round 4 below. Crochet around your first square:

**Round 4:** Attach yarn A to a corner-sp, (ch3, 2dc, ch2, 3dc) in same sp, *ch1, 3dc in next ch-sp, ch1, 3dc in next ch-sp, ch1, (3dc, ch2, 3dc) in next ch-sp, rep from * twice, (3dc in next ch-sp, ch1) twice, join round with sl st, fasten off. (48 sts)

Crochet around your other squares:

**Round 4 + crochet squares together (1 side):** Attach yarn A to a corner-sp, (ch3, 2dc, ch2, 3dc) in same sp, (ch1, 3dc in next ch-sp) twice, ch1, (3dc, ch1, 1sc in ch-sp of adjoining square, 3dc) in next ch-sp, (1sc in ch-sp of adjoining square, 3dc in next ch-sp) twice, 1sc in ch-sp of adjoining square, (3dc, 1sc in ch-sp of adjoining square, ch1, 3dc) in next ch-sp, (ch1, 3dc in next ch-sp) twice, ch1, (3dc, ch2, 3dc in next ch-sp, (ch1, 3dc in next ch-sp) twice, ch1, join round with sl st.

**Round 4 + crochet squares together (2 sides):** Attach yarn A to a corner-sp, (ch3, 2dc, ch2, 3dc) in same sp, (ch1, 3dc in next ch-sp) twice, ch1, *(3dc, ch1, 1sc in ch-sp of adjoining square, 3dc) in next ch-sp, (1sc in ch-sp of adjoining square, 3dc in next ch-sp) twice, 1sc in ch-sp of adjoining square, rep from * once, (3dc, ch2, 3dc) in next ch-sp, (ch1, 3dc in next ch-sp) twice, ch1, join round with sl st. Continue in this way until all 36 granny squares are joined into a 6 x 6 square.

07 Join the bird motifs to the blanket. Choose 6 different colored bird

## Abbreviations

**(US terms used throughout)**

**ch:** chain
**ch-sp:** chain space
**dc:** double crochet
**dtr:** double treble crochet
**hdc:** half double crochet
**sc:** single crochet
**sl st:** slip(ped) stitch
**sp:** space
**tr:** treble crochet
US/UK differences:
US sc (single crochet) = UK dc (double crochet)
US tr (treble) = UK dtr (double treble)
US hdc (half double crochet) = UK htr (half treble crochet)
US dc (double crochet) = UK tr (treble crochet)
US dtr (double treble crochet) = UK ttr (triple treble crochet)

motifs to be joined to the first edge of the blanket. You will first add rounds to make the bird motifs into squares and then attach them to the blanket edge.

**Round 1:** Using G6 crochet hook and yarn A, attach the yarn to the 3rd st from the tail on the bottom edge of the bird, ch3 (counts as 1dc), 2dc in same st, ch1, insert your hook through 2 loops at the back of the tail, (3tr, ch2, 3tr) in same place,

on last sc of tail 3dc in next st, ch1, skip 2sc, 3dc in next st, ch1, skip 2sc, (3tr, ch2, 3tr) in next st twice, ch1, skip 3sc, 3dc in next st, ch1, skip 2sc, 3dc in next st, ch1, skip 2sc, (3tr, ch2, 3tr) in next st, ch1, join round with sl st.

**Round 2:** Ch3 (counts as 1dc), ch1, 3dc in next ch-sp, ch1, (3dc, ch2, 3dc) in ch-sp, (ch1, 3dc in next ch-sp) three times, ch1, (3dc, ch1, 1sc in ch-sp of adjoining granny square, 3dc) in next ch-sp, (1sc in

## GRETA TULNER

As well as glass-blowing, Greta is crazy about yarn, and color is her greatest inspiration. After selling her crochet designs for an interior design shop in France, she began selling her creations on Etsy.
www.ATERGcrochet.etsy.com

ch-sp of adjoining granny square, 3dc in next ch-sp) twice, 1sc in ch-sp of adjoining granny square, (3dc, 1sc in corner-sp of adjoining granny square, ch1, 3dc) in corner ch-sp, (ch1, 3dc in next ch-sp, ch1) three times, (3dc, ch2, 3dc) in next corner ch-sp, ch1, 2dc in next ch-sp, join round with sl st.
Fasten off and weave in ends.
Repeat these steps to crochet the bird motifs on the other three sides of the blanket.

08 Crochet four granny squares at the corners of the blanket.
Take the four remaining granny square motifs. Crochet rounds 4 and 5 below around these and attach them in the corners as follows:
**Round 4:** Attach yarn A to a corner-sp, (ch3, 2dc, ch2, 3dc) in the same sp, *ch1, 3dc in next ch-sp, ch1, 3dc in next ch-sp, ch1, (3dc, ch2, 3dc) in next ch-sp, rep from * twice, (3dc in next ch-sp, ch1) twice, join round with sl st, fasten off. (48 sts)
**Round 5:** Ch4 (counts as 1dc and ch1), (3dc, ch2, 3dc) in next ch-sp, (ch1, 3dc in next ch-sp) three times, ch1, (3dc, ch1, 1sc in ch-sp of adjoining bird motif, 3dc) in next ch-sp, (1sc in ch-sp of adjoining bird

motif, dc in next ch-sp) three times, 1sc in ch-sp of adjoining bird motif, (3dc, 1sc in ch-sp of adjoining bird motif, ch1, 3dc) in next ch-sp, (ch1, 3dc in next ch-sp) three times, ch1, (3dc, 2ch, 3dc) in next ch-sp, (ch1, 3dc in next ch-sp) twice, ch1, 2dc in next ch-sp, join round with sl st in 3rd ch of first dc. (60 sts)
Fasten off and weave in ends.

09 Crochet around the blanket in granny pattern and finish the blanket with a scalloped border.
**Round 1:** Attach yarn A to a corner-sp, (ch3, 2dc, ch2, 3dc) in same sp, *(ch1, 3dc in next ch-sp) four times, ch1, 3dc between two granny squares, **(ch1, 3dc in next ch-sp) three times, ch1, 3dc between two granny squares**, rep from ** to ** six times, (ch1, 3dc in next ch-sp) four times, ch1 (3dc, ch2, 3dc) in corner-sp, ch1, rep from * three times, join round with sl st.
**Round 2:** Sl st into corner-sp, ch1 (counts as 1sc), *(1sc, 1hdc, 1dc, 1tr, 1dc, 1hdc, 1sc) in corner-sp, (1sc, 1hdc, 1dc, 1hdc, 1sc) in next ch-sps (total of 34 scallops), rep from * three times, join round with sl st.
Fasten off and weave in ends.

# WORKING THE STITCHES

FOLLOW THE INSTRUCTIONS FOR WORKING THE HAND EMBROIDERY STITCHES USED FOR THE BOOK'S MAKES.

## Cross stitch

**Starting a thread:** knot the long end of the wool; insert needle through the front of your work a few holes away in the direction you will be stitching; when you reach the knot, snip it off.

**Working cross stitch – method 1**
Working left to right, make a row of diagonal stitches. Up at 1, down at 2, up at 3. Repeat. Working right to left, complete the Xs with a row of diagonal stitches. Up at 4, down at 5, up at 6. Repeat.

**Working cross stitch – method 2**
Work left to right. Up at 1, down at 2, up at 3.Down at 4, up at 5.Repeat.

**Finishing a thread**
Slide the needle through five to six stitches on the back of your work to secure and finish off the thread.

## Running stitch

Work right to left. Up at 1, down at 2. Up at 3, down at 4. Repeat.

## Backstitch

Work right to left. Up at 1, down at 2. Up at 3, down at 4. Repeat.

## Stem stitch

Work left to right. Up at 1, down at 2. Up at 3, down at 4. Repeat.

## Chain stitch

Work right to left. Up at 1, down at 1, keeping thread in a small loop. Up at 2, down at 2, keeping thread in a small loop. Repeat.

## Lazy daisy

Up at 1, down at 2, keeping thread in a small loop. Up at 3, down at 4, basting loop in place.

## French knot

Up at 1. Wrap thread around needle twice. Down at 2, holding thread taut around needle while pulling through.

## Herringbone stitch

Work perpendicular lines. Up at 1. Down at 2, up at 3. Down at 4, up at 5. Repeat.

## Blanket stitch

Start by coming up at the edge. Down at 1 and up at 2 under fabric edge, keeping the needle over the working thread. Repeat.

# TEMPLATES

ALL THE SHAPES FOR THE BOOK'S MAKES. ENLARGE ALL TEMPLATES BY 200% BY PHOTOCOPYING THE PAGES WITH THE EXCEPTION OF THE RETRO-FABRIC BIRD CUSHION, WHICH SHOULD BE ENLARGED BY 400%. YOU CAN ALSO FIND THE FULL-SIZE TEMPLATES READY TO DOWNLOAD FROM WWW.LOVECRAFTS.CO.UK

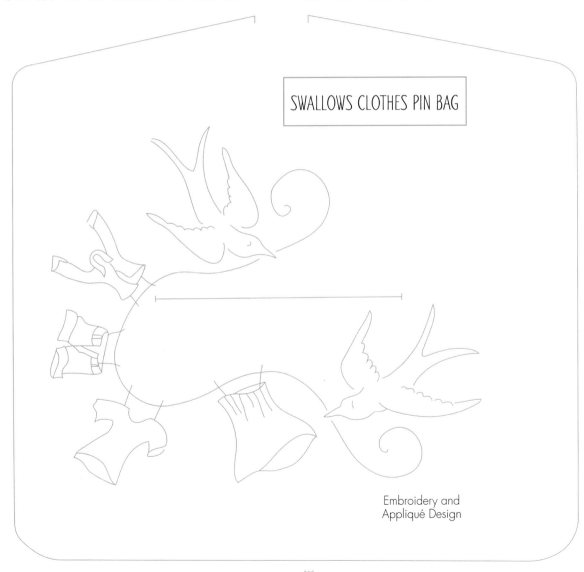

SWALLOWS CLOTHES PIN BAG

Embroidery and
Appliqué Design

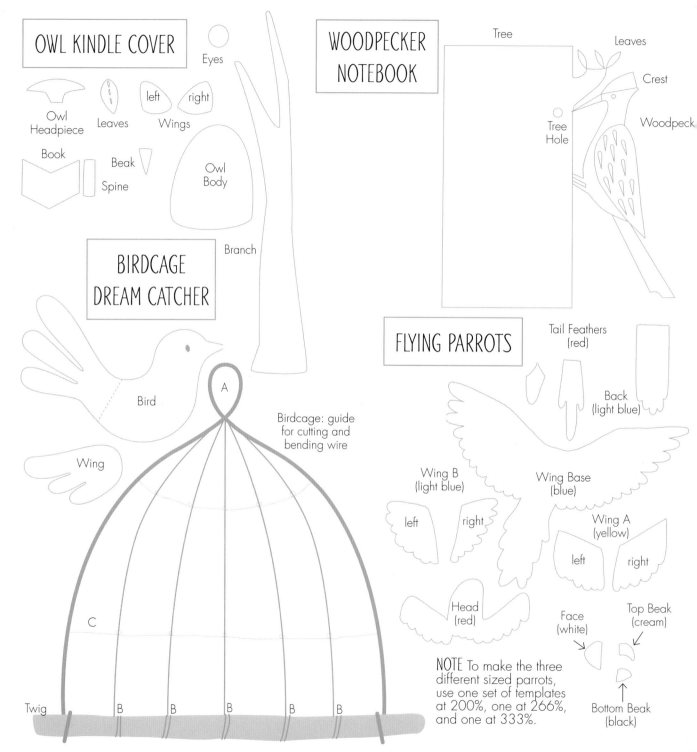

## OWL KINDLE COVER

Eyes

Owl Headpiece

Leaves

Wings
left · right

Book

Beak
Spine

Owl Body

Branch

## BIRDCAGE DREAM CATCHER

## WOODPECKER NOTEBOOK

Tree

Leaves

Crest

Tree Hole

Woodpeck

Bird

A

Wing

Birdcage: guide for cutting and bending wire

C

Twig

B   B   B   B   B

## FLYING PARROTS

Tail Feathers (red)

Back (light blue)

Wing B (light blue)
left · right

Wing Base (blue)

Wing A (yellow)
left · right

Head (red)

Face (white)

Top Beak (cream)

Bottom Beak (black)

NOTE To make the three different sized parrots, use one set of templates at 200%, one at 266%, and one at 333%.

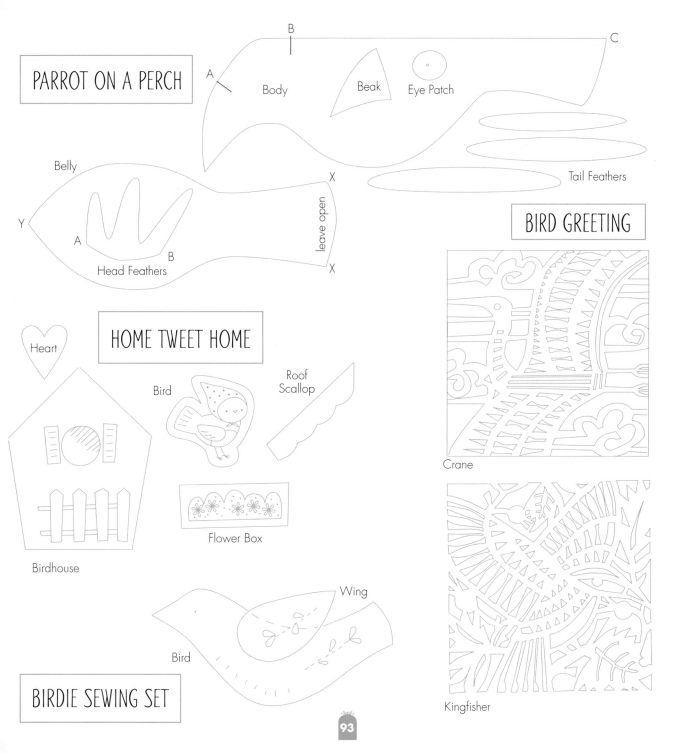

# PARROT ON A PERCH

B

C

A

Body

Beak

Eye Patch

Belly

Tail Feathers

Y

A

Head Feathers

B

X

leave open

X

# BIRD GREETING

# HOME TWEET HOME

Heart

Bird

Roof Scallop

Birdhouse

Flower Box

Crane

Kingfisher

Wing

Bird

# BIRDIE SEWING SET

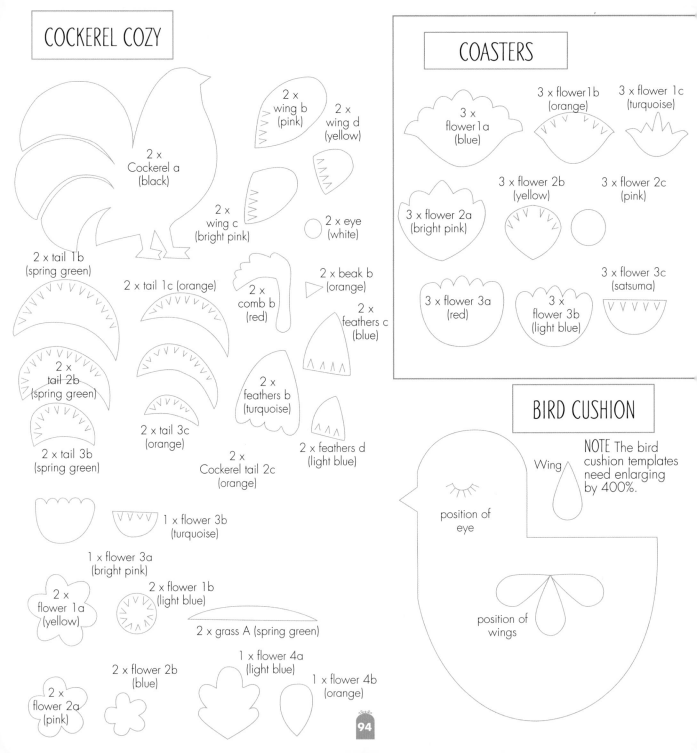

# COCKEREL COZY

2 x
Cockerel a
(black)

2 x wing b
(pink)

2 x wing d
(yellow)

2 x wing c
(bright pink)

2 x eye
(white)

2 x tail 1b
(spring green)

2 x tail 1c (orange)

2 x comb b
(red)

2 x beak b
(orange)

2 x feathers c
(blue)

2 x tail 2b
(spring green)

2 x feathers b
(turquoise)

2 x tail 3c
(orange)

2 x tail 3b
(spring green)

2 x Cockerel tail 2c
(orange)

2 x feathers d
(light blue)

1 x flower 3b
(turquoise)

1 x flower 3a
(bright pink)

2 x flower 1a
(yellow)

2 x flower 1b
(light blue)

2 x grass A (spring green)

2 x flower 2b
(blue)

1 x flower 4a
(light blue)

1 x flower 4b
(orange)

2 x flower 2a
(pink)

# COASTERS

3 x flower 1a
(blue)

3 x flower 1b
(orange)

3 x flower 1c
(turquoise)

3 x flower 2a
(bright pink)

3 x flower 2b
(yellow)

3 x flower 2c
(pink)

3 x flower 3a
(red)

3 x flower 3b
(light blue)

3 x flower 3c
(satsuma)

# BIRD CUSHION

Wing

NOTE The bird cushion templates need enlarging by 400%.

position of eye

position of wings

# LOVING LOVEBIRDS

Key  991  481  251A  331  844
     698  946  254   855  187

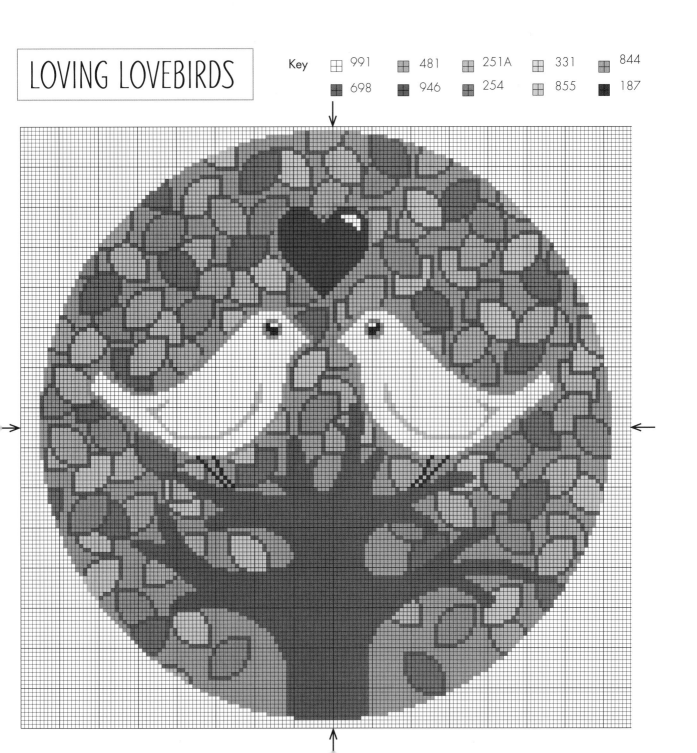

# DELIGHT IN HANDMADE ACCESSORIES
## with these inspirational titles from Interweave

**BEST OF STITCH**
Bags to Sew
Tricia Waddell | $26.95
ISBN 978-1-59668-602-1

**PATCHWORK, PLEASE!**
Colorful Zakka Projects
to Stitch and Give
Ayumi Takahashi | $22.95
ISBN 978-1-59668-599-4

**MOLLIE MAKES CHRISTMAS**
Living and Loving a Handmade Holiday
Various Contributors | $12.95
ISBN 978-1-62033-101-9

For more information
on *Mollie Makes*,
please visit
molliemakes.com

First published in the United States in 2013 by
Interweave Press LLC
A division of F+W Media, Inc.
201 East Fourth Street
Loveland, CO 80537
interweave.com

ISBN 978-1-59668-775-2

Library of Congress Cataloging-in-Publication
Data not available at time of printing.

10 9 8 7 6 5 4 3 2 1

Manufactured in China by 1010.

## PUBLISHER'S ACKNOWLEDGMENTS

This book would not have been possible without the input of all our crafty contibutors. We would
also like to thank Cheryl Brown, who has done a brilliant job of pulling everything together, and
Sophie Martin for her design work. Thanks to Mollie Johanson for allowing us to use her stitch
diagrams and Kuo Kang Chen for his excellent charts.

Project photography by Rachel Whiting, as follows: p7, 11, 15, 21, 25, 29, 37, 41, 45, 49, 53,
57, 61, 69, 73, 77, 81, 85.

And of course, thanks must go to the fantastic team at *Mollie Makes* for all their help, in particular
Jane Toft and Katherine Raderecht.